Postcard History Series

Jones Beach

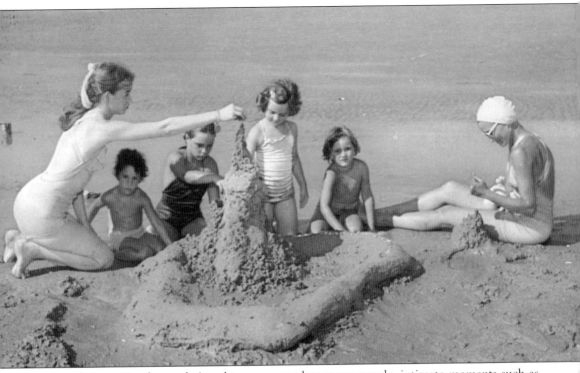

Though Jones Beach was designed to accommodate many people, intimate moments such as this could not be denied. This gentle postcard scene defines the Jones Beach experience just as much as those postcard images found in this book that feature the beach with an apparently limitless crowd. (Author's collection.)

ON THE FRONT COVER: For more on this 90-foot-tall mast, see page 51. (Author's collection.)

ON THE BACK COVER: For more on this beach scene, see page 82. (Author's collection.)

POSTCARD HISTORY SERIES

Jones Beach

Constantine E. Theodosiou
Foreword by George Gorman Jr.

ARCADIA
PUBLISHING

Published by Arcadia Publishing
Charleston, South Carolina

Printed in the United States of America

Library of Congress Control Number: 2017945929

For all general information contact Arcadia Publishing at:
Telephone 843-853-2070
Fax 843-853-0044
E-mail sales@arcadiapublishing.com
For customer service and orders:
Toll-Free 1-888-313-2665

Visit us on the Internet at www.arcadiapublishing.com

To Manoli and Antonia: May all your days be nothing but beach days.

Contents

FOREWORD

I would like to thank Constantine Theodosiou for giving me the honor to write the foreword to his vintage postcard book on Jones Beach.

Jones Beach State Park was the vision and creation of Robert Moses, the master builder of many projects within New York State. He considered Jones Beach one of his crown jewels. It is a magnificent facility that is a mini vacation destination for millions of New Yorkers and visitors. The main attraction is swimming in the Atlantic Ocean, but it is much more than that. Jones Beach provides a respite and escape so that individuals can relax and rejuvenate.

I grew up in Wantagh, which is the gateway to Jones Beach, and my first remembrance as a child going to Jones Beach was the "Pencil in the Sky," which is the world-famous landmark Jones Beach Water Tower. For those of you who are unaware, the Jones Beach Water Tower is a steel cylinder inside a brick facade holding over 300,000 gallons of fresh water that serves the park. My parents would gather their seven children into our station wagon and travel the Wantagh Parkway until we reached Parking Field 4. We would then walk to the beach through the tunnel underneath the Ocean Parkway while screaming so we could hear our echoes.

I began my career in 1977 as a summertime employee at Jones Beach while attending college. Right away, I knew it was a special place. The employees were friendly and outgoing, and they were high school and college students. The park visitors were extremely happy to go to Jones Beach to enjoy the recreational facilities. It was a very positive experience. One of the best parts of my job, believe it or not, was taking a pick-up stick and bag and heading onto the beach to pick up litter. Early in the morning with very few visitors on the beach, I went back to nature and enjoyed the serene calmness of the ocean, and later in the day, cleaning the beachfront park, visitors offered me refreshments, hot dogs, and hamburgers.

Today, I manage the day-to-day operations of all New York state parks on Long Island, but I never left my roots and I am continuously involved with the management of Jones Beach. This postcard book will produce many smiles from its readers who will go back in time and relive some of their happiest moments. It will be nostalgic and emotional but in a very positive and meaningful way.

Enjoy the fond memories you will experience while reading this book.

—George Gorman Jr.
Deputy Regional Director
New York State Office of Parks, Recreation and Historic Preservation

ACKNOWLEDGMENTS

As much as I would like to say that writing this book was like a day at the beach, that was not the case. Far from it! But the experience was rewarding nonetheless.

My thanks go to many people. I would like to first extend my heartfelt appreciation to Hofstra professor emerita Natalie Naylor, editor of the *Nassau County Historical Journal*. Her exacting standards, à la Robert Moses, ensured that this book did justice to its subject. Warm thanks go to George "Chip" Gorman Jr. for writing the foreword. His abiding love of Jones Beach was reason enough for me to do the job right. Susan Precker's role is no less important, for it was she who first spoke to Chip on my behalf and gladly heard me when he could not be reached. My buddy Jason Antos offered his advice, humor, and perspective. Thanks go to Debra Willett, senior library assistant at the Long Island Studies Institute at Hofstra University; I gained a better sense of H.G. Wells's visit to Jones Beach through the articles she kindly retrieved. Carol Poulos, trustee of the Wantagh Preservation Society, recalled the fondness some older residents had for the Wantagh Hotel, now gone. Little details like these mean a lot.

I would be remiss if I did not extend my love and gratitude to my wife, Victoria, and my children, Manoli and Antonia. Despite Vicky's pleas that I get on with my share of the housework, her support never wavered. With the light she shines on my life, Antonia inspires me to do what needs to be done in the best way possible. I hope this book will show that. Still, it would not have gotten very far were it not for Manoli's role as loyal sidekick. It was he who first spotted many of the wonderful postcards you will soon enjoy. Yet the tender moments they engendered between us go beyond this scope of this book. They forever comprise a special part of my own Jones Beach memories.

All postcards in this book are from the author's collection.

INTRODUCTION

Public beaches cannot be considered luxuries but necessities which contribute directly to the health,
well-being and pleasure of the people.

—Robert Moses

Picture postcards really excite me.

—Henry Miller, *My Life and Times*

The speed and scope of online communication today go hand in hand, something we take for granted. Yet our fondness for all things digital also distances us from the time when the Internet was the stuff of science fiction and picture postcards were our social media. We naturally turned to them while on vacation; nothing, it seemed, reflected our minds at peace better. And while unassuming, postcards were on hand nearly everywhere: in hotel and motel lobbies, gift shops and rest stops, local drugstores (on thin metal racks that squealed in protest if spun too fast), roadside diners, and service stations. "Posting something" meant jotting down a timely note and mailing it to the right address. Then, after a few days, came the desired connection, when friends and family were thrilled (or jealous) to finally hear from us. Whether in the giving or in the receiving, the significance of postcards was real.

Any catalog of picture postcards from domestic travel destinations over the last century would be incomplete without those of Long Island's state park system. High on this list were those of Jones Beach State Park, better known simply as Jones Beach. With depictions of the resplendent Atlantic and wholesome activities the public could enjoy, all at reasonable cost, these postcards were designed to promote Jones Beach's air of respectability. Their styles tended to be decade-specific: watercolor and lithographic cards—known today as real-photo postcards or RPPCs—surfaced in the 1930s; vibrant color linens, in the 1940s; and truer-to-life Kodachromes, thereafter. Altogether, these postcards constitute the mosaic of the Jones Beach experience.

Jones Beach postcards also reflect a time when enlightened public service was a discernible part of our lives. Not only were visitors impressed with Jones Beach's swanky appearance (hailed as a game changer when it first opened in 1929), or how it catered to their want of leisure, or what it offered by way of public entertainment, but they also left knowing that their government was serving them in their best interest, as it should.

The Making of a Dignified Public Beach

For much of the 20th century, Jones Beach was the crown jewel of Long Island's public beaches. But, as is often the case with great undertakings, its birth did not come easy.

As fate would have it on August 4, 1929, a sandstorm besieged Jones Beach's opening ceremony. Among the dignitaries braving the whipped-up sand was the man of the hour, the president of the Long Island State Park Commission (LISPC), Robert Moses. Jones Beach was his brainchild, and it was he who oversaw it to completion—although, as the storm raged, few could tell that some parts of it remained unfinished.

Still, Moses had every reason to feel exultant. While trying to improve the well-being of Gotham's middle class (given the historical controversy that surrounds Robert Moses's legacy, we forget that he began his career in public service as a reformer), he had to surmount legal, political, and bureaucratic hurdles for the better part of a decade. State officials in particular mistrusted him and were scornful of his idealism. "Trouble was," Moses later said, "those guys couldn't see anything bigger than a hat rack." But he certainly did. Jones Beach embodied his expressed belief that the public deserved the best from its government. The success of the state-planned and -executed park

under his supervision stood to repudiate the cynical market-based approaches that gave rise to its older and more decadent sibling in Brooklyn.

Rejecting Coney Island's honky-tonk ways as a matter of principle, Moses looked to transform a near-empty barrier island off Long Island's South Shore, 33 miles east of Manhattan, into a shorefront park that would capitalize on the liberating effects of the Atlantic Ocean. It was a worthy aim, but not universally embraced, something Moses acknowledged in 1974: "Our concept of matchless shorefront public recreation park open to everyone . . . was still generally regarded by the natives with suspicion and dislike." The locals cynically referred to his project with a catchy alliteration: Moses Madness.

Yet Robert Moses would not be deterred. He appealed to local officials to donate requisite land, submitted propositions for public referenda, and resorted to eminent domain. Pragmatic to a fault, he (supposedly) saw fit to offer a building contract to the brother-in-law of G. Wilbur Doughty, Hempstead's powerful town supervisor, in exchange for Doughty's support to have five miles of Hempstead's barrier beach ceded to the state, in effect voiding the outcome of a referendum in the town of Hempstead the year before. On the ground, Moses had his men forcibly evict a defiant hotel owner named Ellison from land earmarked for a parkway. That Ellison was head of the local chapter of the Ku Klux Klan justified his eviction in Moses's eyes, or so Moses claimed years later.

And there were legal battles. One high-profile dispute, the Seaman-Gore case, called into question the validity of royal grants from the colonial period as they applied to the heirs of John Seaman, who sought to prevent the state from usurping what was rightfully theirs. The case dragged on for 10 years before the US Supreme Court decided in the state's favor.

During that time, Moses found himself in the thick of a clash between the force of progress and the power of privilege. Being avid duck hunters, the Guggenheim family leased property from the Town of Oyster Bay in 1925 for a private shooting box on a spot where beach construction was to begin. The family sought an injunction to stop the building; the state (through Moses) got a hold of, and canceled, their lease. Emotions on both sides ran high. The Guggenheims branded Moses "Lord Robert" and his men "Cossacks" in the local press, maintaining that no one should begrudge the family's request as a small recompense for its past philanthropy. Moses railed at this and countered by exposing the Guggenheims as having abetted the mindless slaughter of birds.

Once under way, Jones Beach's sense of refinement set it apart from existing public beaches. But the key to enjoying it was in how park officials expected its amenities to be taken for granted. From the lifeguards to the lowlier hands, employees were required to be impeccably dressed and to act with civility and purpose. As part of the park's "courtesy squads," boardwalk sweepers executed their tasks in white, navy-like uniforms. Visitors, meanwhile, were expected to show decorum even from the moment they arrived, for they risked a stern talking-to if they were caught undressing in the parking fields rather than in the bathhouses. (Lifeguards were instructed to set their sights to the parking fields in the distance behind them—pretty sneaky, but park officials felt it set the right tone.)

Jones Beach assumed a nautical theme inspired during the Jazz Age. The park bore the appearance of an ocean liner, with its mile-long boardwalk with varnished mahogany railing resembling the deck. Nautical-styled trappings on the boardwalk (purposely designed as such to preserve the illusion) obscured their mundane purposes: water fountains assumed the form of binnacles, ship funnels concealed trash bins, and faux life preservers were generous-sized ashtrays. Though contrived as park themes usually are, Jones Beach's was well-received during the Great Depression years for the way it seemed to lift the spirit.

Another prominent feature of Jones Beach was its architecture, two fine examples being the sumptuous East and West Bathhouses. Built in 1930 and 1931 respectively at a hefty cost of $1 million each—at the time when $1 million was allocated for the entire Long Island state park system—both edifices are striking, if dissimilar. Moses insisted on using Barbizon brick and Ohio sandstone, as the red, tan, and brown coloring of the first harmonized with the sand, and the tan, blue, and gray of the latter (for the bathhouses facades) corresponded with the sea and

sky. Appearances aside, both were built to handle more than 10,000 daily visitors. But the park's grandest structural presence is the handsome water tower. Standing slightly more than 230 feet tall and marking the spot where beach construction began, the Venetian-inspired structure has long transcended its utilitarian purpose to be a beloved icon in the minds of people, especially motorists on the Wantagh Parkway whom it beckons.

That Jones Beach was geared to please its visitors could not be overstated. It was something the *Saturday Evening Post* referred to in 1941: "Flowers, lawns, shrubs greet you instead of papers, lunch boxes, and dirt. Nothing is crowded, the sidewalks are wide, the buildings are low and attractively designed." Most of all, "the beach is apparently endless." At six and a half miles, no one could argue with that, but the shorefront was just part of the picture. Present also was an array of wholesome activities: orchestral events, calisthenics classes, shuffleboard, archery, a pony track, pitch and putt golf, miniature golf, paddle tennis, horseshoes, bocce, row-boating, and handball. Off Zachs Bay, children frolicked in playgrounds anchored in the sand. For years, the West Bathhouse boasted two saltwater pools, one of which was lit for night swimming, a novelty when it was introduced. (The first of two saltwater pools was installed in the East Bathhouse only in 1967.) All this was to give ordinary people a slice of the good life.

And yet, many would just enjoy strolling on paths lined with peonies, marigolds, and chrysanthemums in full bloom, or on the boardwalk for the sea air. Children hopped over to the Indian Village where, along with partaking in arts and crafts, they listened in as Rosebud Yellow Robe regaled them with tales of the Lakota people. Open-air dances were routinely held at the band shell during the evening hours. Musicals at the Marine Theater under Guy Lombardo came to define a beloved era at Jones Beach. All of this manifested Moses's view that proper outdoor activity fostered a healthy society.

The meaning of this was somehow not lost on English author and social critic H. G. Wells. When he came to the United States in the middle of October 1931, as the Great Depression's impact was being felt worldwide, he believed that civilization was on the verge of "probable collapse." But after seeing Jones Beach, Wells remarked that it was "one of the finest beaches in the United States and almost the only one designed with forethought and good taste." Someone would point out that this was a rare act of understatement on Wells's part, but who's not to say that as he left Jones Beach he did so with some renewed optimism after all?

Jones Beach Makes Its Splash

As impressive as Jones Beach was, Robert Moses first had to broaden access to a part of Long Island that some wanted to keep for themselves. Determined to stop him, members of the High Hill summer community requested a meeting with Gov. Alfred E. Smith. Yet when they raised the implications of allowing city "rabble" into their vicinity, the governor (proud of his own city roots) bristled: "Those are my people you're talking about!" Smith's response characterized the depth of political support Moses felt was indispensable to his work.

But it was Smith's successor, Franklin D. Roosevelt who articulated Jones Beach's purpose at the cornerstone laying ceremony for the East Bathhouse in 1929: "This cornerstone is only a symbol, only stone and mortar. The real cornerstone is the health and happiness of dozens of generations of New Yorkers." The meaning of this statement resonated years afterward. According to data compiled by the Long Island State Park Commission in 1933, Jones Beach welcomed 1.75 million visitors in 1930; the number swelled to 2.7 million the following year. In 1932, the number who came to Jones Beach escalated to 3.2 million. Twenty years after that, in 1952, Jones Beach attracted a whopping 8 million visitors, one for every resident of New York City.

Architecture critic Paul Goldberger, observing that sound architecture and planning are pillars to civilized society, considers Jones Beach one of the few places in the country where such a standard was consciously met. In a 1998 interview, he lamented that "Jones Beach represents . . . a reminder that we've given up on this whole idea of the public realm. . . . We don't make things half as good as Jones Beach anymore." And so, it appears we have come full circle. As it is all but

certain that the state will no longer prioritize the construction of places as noble as Jones Beach for the common good, offering leisure to people is again left to private enterprise. "Fun-filled" theme parks have since resurfaced and proliferated across the country, bedeviling visitors once more with stomach-churning rides and the din of their attractions.

Which brings us to the significance of Jones Beach's postcards. First, let's reflect on the demise of postcards in general. As their stories are all but silenced over time—and who is to say that, in the end, those of Jones Beach are any different?—they are often relegated to forgotten shoeboxes, brittle scrapbooks, and (assuming they survived this far) postcard shows. But to anyone who wishes to understand the historical importance of a place like Jones Beach, postcards become useful as artifacts.

By portraying Jones Beach as the tour de force that it was, its postcards corroborate the view that a new standard was instituted for public beaches. By showing how its visitors were offered a slice of the good life—and by an arm of state government no less—these postcards are a testament to how, with Jones Beach's success, our democratic spirit took a proud step forward.

But leave that to the historian or social scientist. On a postcard dated in 1932, "Maria" seems to capture what many would have though after spending a day spent at Jones Beach: "A most immaculate beach. The cleanest & best place I ever stumbled into."

That would have suited Robert Moses just fine.

"Conservation in a Broader Sense"

As alluded to earlier, it was Moses's aim for the public to regard Jones Beach as a worthy alternative to Coney Island's kitsch. Yet as tacky as Coney Island was—the same tackiness that accounted for its timeless appeal—from it came some eye-catching postcards. True to its type of spectacle, their images still evoke the time when Surf Avenue stood virtually alone as the place New Yorkers flocked to to escape their everyday. But to author Richard Snow, the popularity of Coney Island postcards was also due to good timing, "published between the turn of the century and the First World War. With their fierce, spurious colors and inexhaustible willingness to show alike the tallest minaret and most meager sideshow, they are the best and truest record we have of Coney Island at its tawdry, cunning, magnificent zenith."

By contrast, the tone of Jones Beach's picture postcards was more conservative and subdued. Given its sophistication, its postcards naturally called for sophisticated images. Maybe this was because the LISPC—even Robert Moses himself—wished to avoid public disapproval. (Remember, Jones Beach was a *public* beach.) Such caution also meant that most postcard images were often repeated as the years passed with little or no variation.

Why, then, do a postcard history on Jones Beach? In part, the reason is because some early postcards offer a view of an idyllic part of Long Island worth remembering. One look and you sense how excited Moses was that Long Island, its storied coastline in particular, was an ideal setting for harried New Yorkers to spend their leisure time. Later, they would reveal Jones Beach's zeitgeist: its signature architecture and landscaping, access to the Atlantic, and just as important, its recreational activities, rather than the shoddy amusements that were all too common elsewhere.

Though many of Moses's critics conceded that Jones Beach was groundbreaking, they would also point out that it is tainted by the Master Builder's high-handed ways. That may have indeed been true and even a sign of things to come. But seeing the number of enthusiasts who would come over the years, such criticism melted like ice cream under an August sun. As Moses himself put it: "Here it is in a nutshell. [Jones Beach is] an example of planned, imaginative, persistent, nonpolitical public enterprise. This is conservation in a broader sense. . . . When the critics tell you that there has been nothing but neglect of the great outdoors, take them to Jones Beach . . . and tell them to look around about them."

Using postcards as our guide, let's see just how right he was.

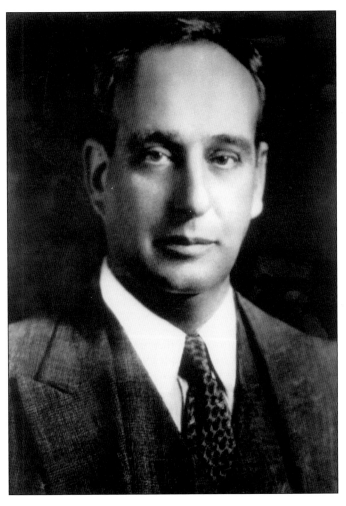

Robert Moses (1888–1981) was the founder of Jones Beach State Park. A visionary, Moses stopped at little in his 44-year career in public service to transform the greater New York metropolitan area into a 20th-century landscape. At one point, the Master Builder held as many as 12 city and state posts simultaneously, including president of the Long Island State Park Commission and chairman of the State Council of Parks (1924–1963). On Long Island, Moses was responsible for the construction of 15 parkways and expressways and 19 state parks, with Jones Beach as the crown jewel (it was also his personal favorite). Widely regarded as Moses's most inspired public work, Jones Beach today enjoys landmark status and an international reputation. This picture of the Master Builder was taken in 1934.

One

SHOREFRONT ORIGINS

From Rockaway Inlet in Queens towards Suffolk County, Long Island's South Shore is shielded by a string of barrier islands. These form the southern edge of the Great South Bay, a magnificent body of water that has long been a favorite of yachtsmen. They also made for numerous beachfront Shangri-las: Hemlock Beach, Oak Beach (both part of today's Gilgo Beach), Short Beach, and Fire Island.

Among these barrier islands was Jones Island, a 17-mile-long, mile-wide sandbar that Robert Moses set his sights on two centuries after it was first named. "Let us have no illusions about Jones Beach as we found it," he later maintained. "It was an isolated, swampy sand bar accessible only by small boats and infrequent ferries The tales told of a lovely primitive, paradise wilderness with indestructible dunes were fiction." But he left it smitten and inspired enough to build a public beach par excellence.

Along Zachs Bay, where the dunes were high, was the perennial summer community of High Hill Beach (Jones Beach's Field 9, closed to the public since 1977). At its peak, it comprised nearly a hundred seasonal and permanent dwellings, two small hotels, a general store, and even a post office. Getting there made for an onerous trip, something author Birdsall Jackson noted:

> In a sailboat with a fair wind, the trip to Jones Beach took about one hour, and a head wind, three hours. If you are not familiar with the many shoals and crooked channels you would not get there at all. An excursion to Jones Beach was always planned as a full day's outing and the day chosen so the voyager went out with the ebb tide and came back with the flood. All night sojourns on the sand flats were not uncommon.

Local residents smugly believed this was enough to enable them to continue unmolested (a plus during Prohibition). Embodying their agreeably languid existence was M.F. Savage's pavilion, according to onetime local High Hill resident Bill Wisner (as quoted by John Hanc) "a lumberyard's delight but an architect's nightmare," where the people assembled and bought their provisions. All this changed as a referendum in the town of Hempstead in 1926 officially paved the way for Jones Beach's development. High Hill lingered until 1939, a shadow of its former self, when Moses relocated whatever remained to today's West Gilgo Beach.

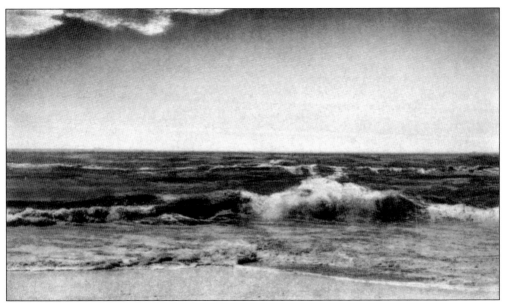

This simple yet appealing image of waves breaking gently on the shore bespeaks what inspired Robert Moses to build Jones Beach and other beachfront parks on Long Island. As someone with an abiding love of the sea, Moses was convinced that access to the splendor of the Atlantic via Long Island was just what harried New Yorkers and day-trippers needed to rest and rejuvenate.

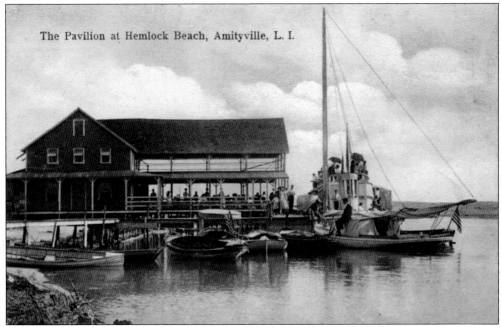

The Pavilion at Hemlock Beach, Amityville, L. I.

While Moses believed that Long Island's seascape was something the masses could benefit from, he was not the first to be charmed by it. During the summer season, native Long Islanders made their way to beachfront enclaves like this in Amityville's Hemlock Beach, a deepwater cove with access to both the ocean and bays. Gilgo Beach State Park stands on this site today. Featured on this postcard is the Pavilion, the place where members of Hemlock Beach's summer colony would congregate.

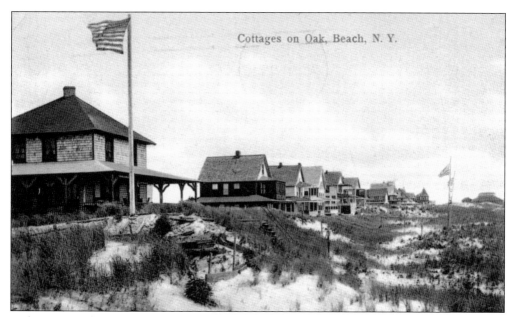

Cottages on Oak Beach, N. Y.

Robert Moses first gazed upon Long Island's environs in 1921. By 1923, he resided on Thompson Avenue in the village of Babylon, and he later rented a house in Oak Beach. Over the years, Moses's fondness for Long Island only grew, as he liked to later call himself a "South Shore boy" and Long Island his "stamping ground the year round." This is a row of Oak Beach's fine seaside cottages. The Bungalow, Oak Beach's gathering place, is in the distance.

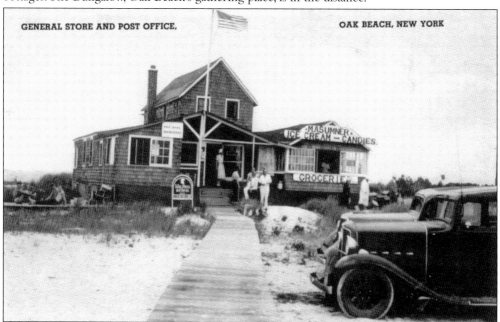

GENERAL STORE AND POST OFFICE, OAK BEACH, NEW YORK

Prominently featured on this fine picture postcard is the general store at Oak Beach that supplied its summer residents with provisions, including candy and ice cream for the youngsters and beer for those who saw themselves as young at heart. Just as important was the local post office (also featured), the lifeline with the rest of society. Here, too, people would gather to catch up with each other's doings.

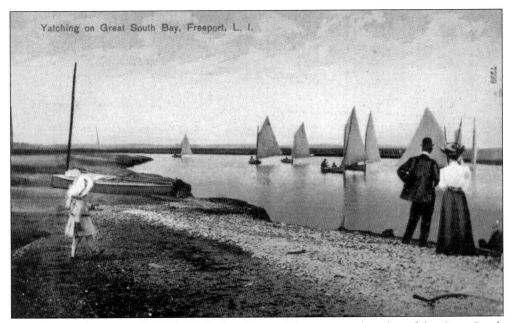

Yatching on Great South Bay, Freeport, L. I.

According to the postcard's label, this is the village of Freeport on the edge of the Great South Bay. A large body of calm water between Long Island's South Shore and Long Island proper, the Great South Bay was home to several barrier beaches. Here, an attentive couple watches boatmen engaged in some leisurely sailing. One could only imagine what their child to the left is thinking.

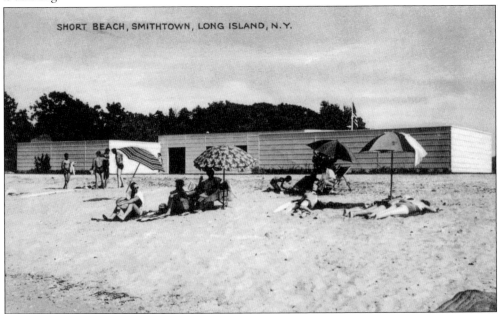

SHORT BEACH, SMITHTOWN, LONG ISLAND, N.Y.

This c. 1930 postcard mistakenly puts Short Beach in Smithtown, when in fact it was on the western part of Jones Island facing the northern shore of the Great South Bay. Short Beach has been home to a local US Coast Guard unit since 1851, when it was a US Life-Saving Service station. Through Robert Moses's intervention in the 1950s, Short Beach was stabilized and developed into what is now the West End.

Jones Beach's predecessor, High Hill Beach, boasted a close-knit community not unlike that of West Gilgo Beach and Fire Island today. Comprised of nearly 100 cottages at the height of its existence, as well as a boardinghouse, hotel-casino, Life-Saving station, and post office, to its residents it was a slice of heaven whose isolation they believed buffered them from any unwanted intrusion. It was in this spirit that, upon learning of Robert Moses's plans, some members appealed directly to Gov. Alfred E. Smith. Sensing their snobbery, Smith rebuffed them. As he saw it, Moses was working on the side of the angels. Though these postcards read like open invites, social expectations at High Hill were such that they were likely to be sent to close friends or family.

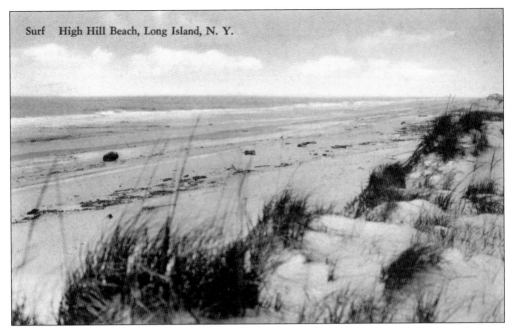

Surf High Hill Beach, Long Island, N. Y.

Seen from the vantage point of the dunes, this expanse of High Hill Beach with the pounding surf and clear horizon makes for a stirring sight. Such a panorama, along with the recreational benefit to be derived from the ocean itself, only made Moses more determined to broaden the beach's access to the greater public.

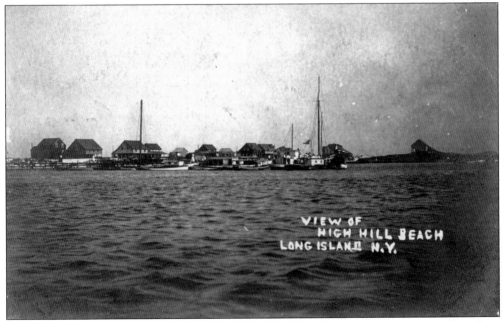

VIEW OF
HIGH HILL BEACH
LONG ISLAND N.Y.

This perspective shows High Hill Beach as one approached it from the bay. Though telling from a historical point of view, this murky postcard rendering reveals that mass-produced photography was still in its infancy. However, as this postcard was postmarked in 1909, its darkened image could also be due to age.

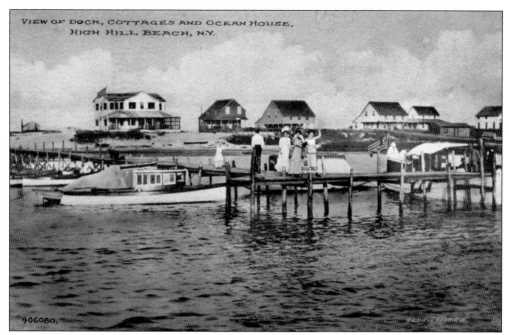

In this undated postcard, the focus is on the three women who have just arrived at High Hill Beach. Standing on the dock, they seem excited at the prospect of having a wonderful time; the woman on the right appears to be waving. Note the sizeable cottages in the background, which closely resemble those in Oak Beach (see page 15).

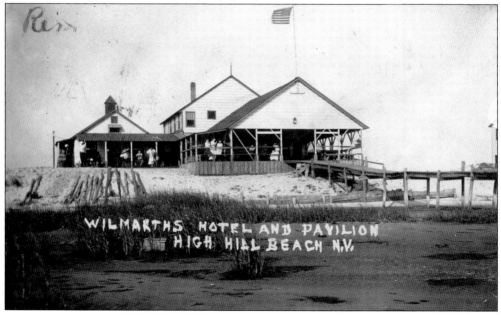

Depicted in this postcard, stamped in 1910, is a rare front view of the Wilmarth's Hotel and Pavilion (later the Sportsmens Hotel), built by R. T. Wilmarth in 1900. In 1917, Wilmarth sold the Sportsmens Hotel to M. F. Savage, who renamed it Savage's Hotel and Casino to highlight the new and sophisticated addition. This image captures some lodgers looking straight into the camera as the photographer crosses their line of sight.

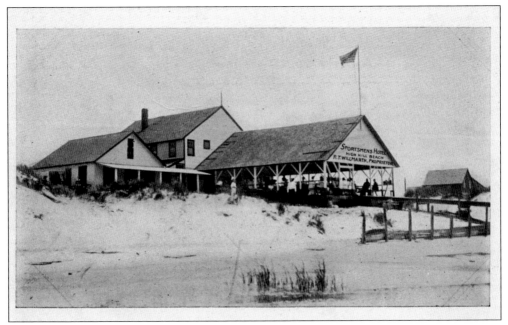

In this view of the Sportsmens Hotel, some people can be seen relaxing under its ample canopy, talking, eating, and playing card games while enjoying cool ocean breezes.

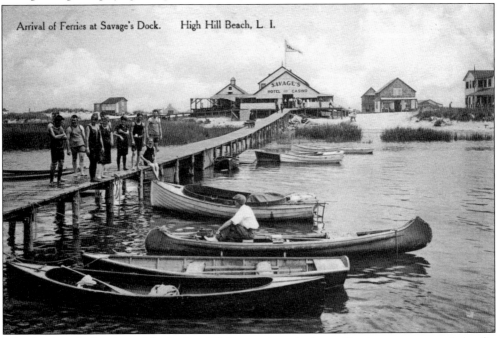

After leaving the hamlets of Seaford and Bellmore, it took about 40 minutes on a good day for ferries to reach High Hill Beach. Yet despite the trip's length—and the pesky horseflies—the ride was seen as part of High Hill's appeal. Passengers disembarked here and headed towards Savage's Hotel and Casino (formerly the Sportsmens Hotel). When Savage took ownership, the Pavilion was a local fixture, appreciated especially during Prohibition thanks to his permissive attitude toward alcohol.

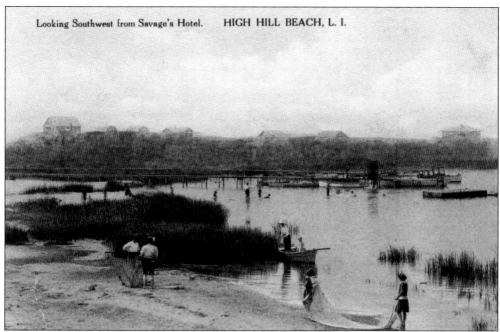

A timeless view shows Zachs Bay southwest from Savage's Hotel. According to Birdsall Jackson, Zachs Bay was named after Zachariah James, "a worthy citizen of Seaford . . . [who was] one of the homeliest men who ever drew breath of life and that his wife was as beautiful as he was homely." Mary held a unique distinction for a woman in that she could sail through the tortuous inlet towards High Hill Beach while using troll lines to catch bluefish.

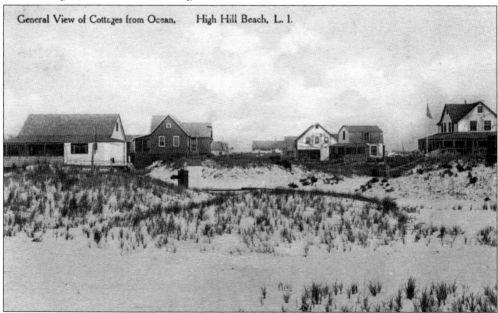

General View of Cottages from Ocean, High Hill Beach, L. I.

Seen from the ocean's perspective is this cluster of seaside cottages. Their proximity to one another enhances the sense of community their inhabitants appreciated. While spacious, these cottages lacked internal plumbing, forcing residents to draw water from common wells or pumps, one being discernible directly before the second house on the left.

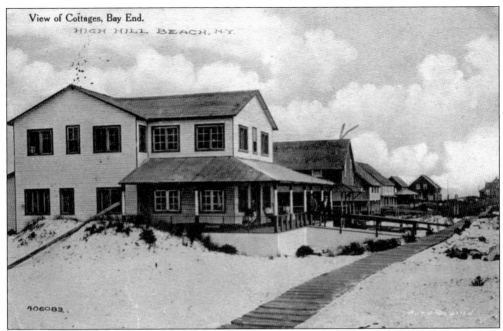

View of Cottages, Bay End.
HIGH HILL BEACH, N.Y.
406083.

A familiar, yet still charming, perspective shows a row of seaside cottages that has changed little over time. What seems to unite them is the rough wooden boardwalk running along their length. Today, Long Island's communities along the South Shore can view High Hill as a kind of forerunner. (After Robert Moses had the High Hill cottages that survived the 1938 hurricane moved to what is now West Gilgo Beach, some have since been winterized to be year-round homes that are the pride of their owners.) In this postcard stamped in 1913, Sara relates how she will be staying with a Mrs. Ketcham for a few days, marking the spot on the postcard accordingly.

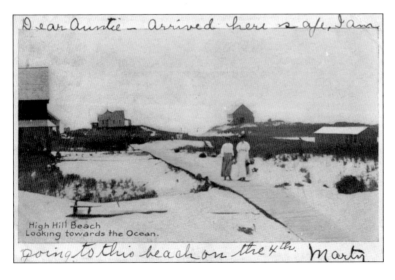

Dear Auntie — arrived here s afe, I am

High Hill Beach
Looking towards the Ocean.

going to this beach on the 4th. Marty

With their backs to the ocean, these women are taking a walk in each other's company. They are fully dressed, which could have been due to the weather as much as social convention. In this 1907 postcard, Marty's salutation of "Dear Auntie" reveals that he too was a part of a family that saw High Hill as its summer getaway.

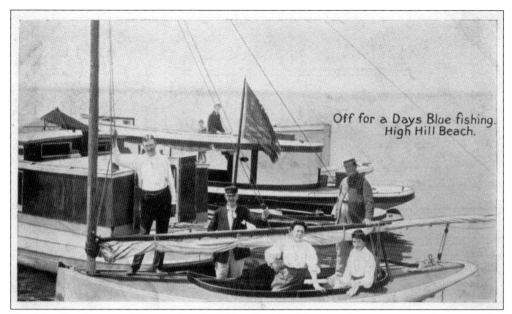

Off for a Days Blue fishing.
High Hill Beach.

For this relaxed party of five, casting their lines for bluefish was a fine way to spend some quality time together. It is more likely that one of the larger boats in this photograph, and not the skiff on which the women are seated, was used to venture to the deeper parts of the Great South Bay, where good catches awaited. While perfectly edible, bluefish (or "blues") were also popular for the good fight they gave on the line. Other sought-after fish included weakfish, kingfish, and deep-sea porgies.

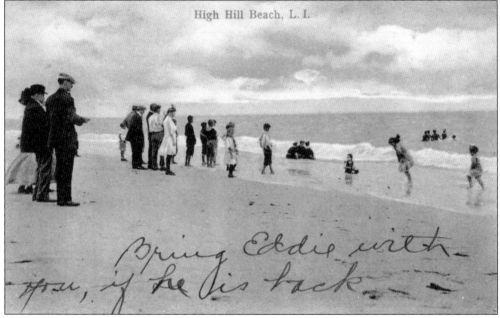

High Hill Beach, L. I.

Bring Eddie with you, if he is back

Judging by the clothing of some of these beachgoers, this is not a typical beach day. In fact, one can sense that it is a bit too cool for a day at the shore. Yet there are some, notably the children under the watchful eye of the adults present, who find the ocean too irresistible not to make the most of it. This postcard was stamped in July 1914.

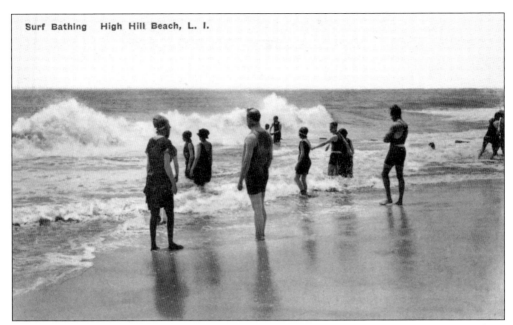

Surf Bathing High Hill Beach, L. I.

Unlike the previous image, this looks like an ideal day to spend by the shore. Note the crashing waves in back, which would have delighted some and, just as likely, annoyed others. Men and women are seen in each other's company, which indicates that social standards were starting to shift when this postcard was issued. Full-body swimwear for both sexes is evident, however.

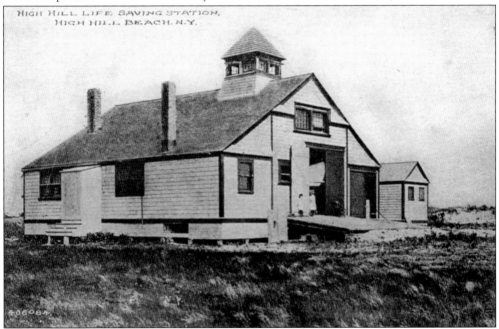

HIGH HILL LIFE SAVING STATION, HIGH HILL BEACH. N.Y.

This postcard depicts the High Hill Life-Saving Station. Such a facility was essential to house the intrepid souls whose livelihood it was to save swimmers (and others) who were literally in over their heads. The station's imposing size is attributable to the massive lifeboat utilized to reach those who strayed in the ocean farther than the lifesavers' individual ability to bring them back. Notice the lifeboat's protruding nose barely visible behind the open doors.

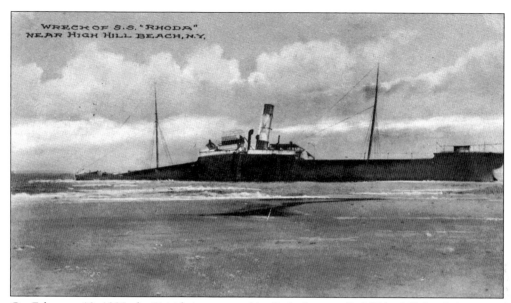

On February 13, 1908, the British iron steamship *Roda* (here spelled "Rhoda") headed to New York from Huelva, Spain, with a cargo of copper ore. Navigating in an evening fog between Jones Inlet and Fire Island in sight of High Hill Beach, she ran aground 100 yards offshore. The protracted operation conducted by the Jones Beach Life-Saving Service—due to the captain's insistence not to abandon ship—resulted in no casualties. The *Roda*'s story, a subject of excited conversation to the locals for days, inspired this postcard rendering.

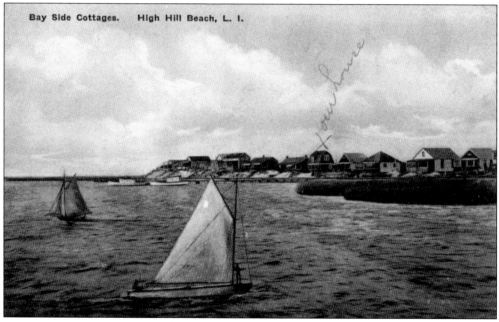

Part of the reason why the *Roda*'s plight figures so prominently in the prehistory of Jones Beach stemmed from her size, which, as she lay beached, looked quite imposing. Typically, local watercraft were little more than fishing boats meant for daily excursions or one- or two-man recreational sailboats, as seen here. As was a common practice by some postcard writers then, Virginia marked off the cottage where she was staying.

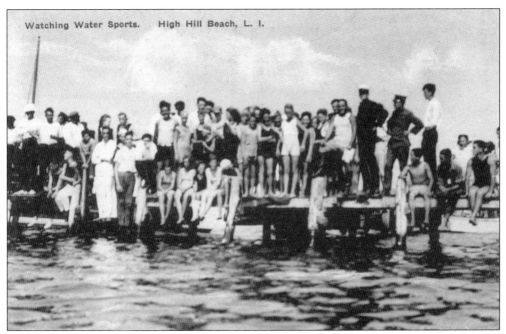

Watching Water Sports. High Hill Beach, L. I.

The sense of joy on the faces of these members of the High Hill Beach community is palpable. While, in terms of numbers, this gathering was far smaller than the throngs of people who later came to Jones Beach, their thrill as they watched the water activity before them is no less real.

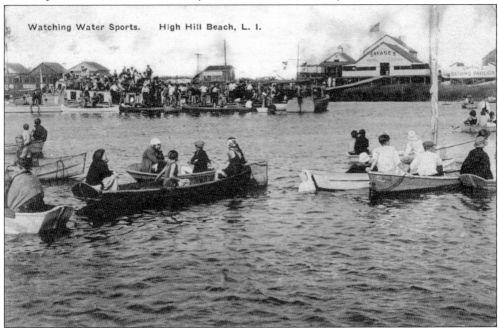

Watching Water Sports. High Hill Beach, L. I.

The delight this postcard brings is not so much in its image, which is analogous to the previous one, but in the message of its sender. Paul wrote to his mother in Michigan that the dock appears to be as full as when he was there, but he goes on to say that "we took about seven hundred people over to the beach this weekend." Does this mean that Paul was part of a crew or maybe the captain? If so, this postcard is special. Note Savage's Bathing Pavilion in the distance.

Two

JUST FOLLOW
THE SEAHORSE!

As Robert Moses commuted from Babylon to work on the train, he noticed tracts of undeveloped land between the communities on the line. Once he ascertained that these were watershed properties that the City of Brooklyn bought back in 1874 and deserted, he had them transferred under the control of the Long Island State Parks Commission (LISPC) for the right-of-way to build his parkways on Long Island.

Since his early posts did not grant him the power to build highways, in 1924, Moses (as head of the State Council of Parks and the LISPC) had legislation drafted to mirror the creation of the Westchester Parks Commission. With that, he could oversee the building of verdant routes to Long Island's state parks, effectively ribbon parks themselves, hence the term "parkways."

While they proved themselves to be indispensable, these roadways remain controversial. In Robert Caro's opinion, Moses felt his parks should be patronized by what he deemed "respectable" people. Such people generally had automobiles; those who did not had to resort to public transportation. But Moses refused to have the Long Island Rail Road build a spur to Jones Beach and had buses banned from his parkways, forcing them to take circuitous routes to his parks. Predicting that this could change someday, Moses saw to it that his bridge overpasses were built with low clearances. Since buses were patronized by African Americans and other nonwhites, Caro laid down the gauntlet: Moses was racist.

Noted urban historian Kenneth Jackson offers a more balanced view. Conceding that Moses scorned the poor and was dismissive of African Americans, Jackson maintains that this was a typical attitude of Moses's time. "The evidence does not support Caro's claims that racism was a defining aspect of Moses' character, or that his actions had a disproportionately adverse effect on African-Americans." Rather, Moses had "a consistent and powerful commitment to the public realm: to housing, highways, parks, and great engineering projects that were open to everyone." Architecture critic Paul Goldberger contends that Long Island's parkways were more for the motorists' enjoyment. After all, Moses believed that car travel signified progress.

Getting to Jones Beach in the beginning was not without an element of fun. Once Moses's parkways led to the Jones Beach Causeway, drivers would encounter Jones Beach's public ambassador, Mr. Seahorse Rampant. Visible on road signs, it pointed them to a fun day at the beach.

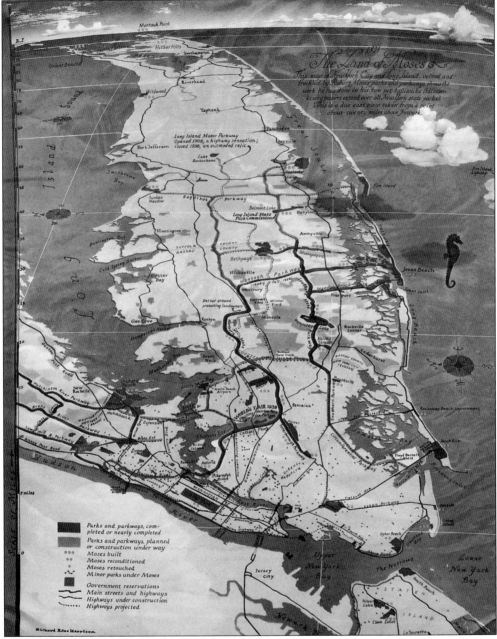

This fine map's perspective is of Long Island in a view eastward towards Montauk Point. Printed for the 1939 New York World's Fair and pretentiously titled *The Land of Moses*, the map was intended to impress the viewer with Robert Moses's mark on Long Island. As the legend indicates, more work, or progress, was forthcoming ("progress" being the operative term of the world's fair itself). Note the arterial highways (better known as parkways) stretching across and the numerous parks dotting the island landscape, each completed under Moses's watch. Of special note is the Wantagh Parkway (at the center of the map) extending towards the Atlantic Ocean, ending with Jones Beach (next the seahorse to the right).

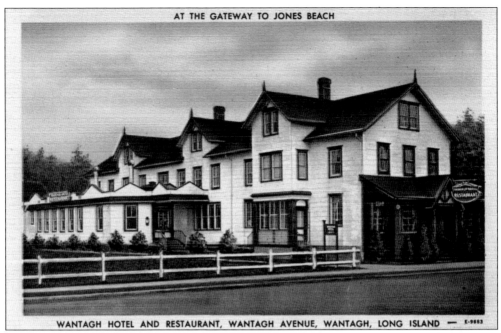

Near the corner of Wantagh Avenue and Sunrise Highway stood the Wantagh Hotel and Restaurant, which opened around 1883. A McDonald's—whose initial appearance led some older residents to wax nostalgic over the delicious sauerbraten and creamed spinach the restaurant once served—sits on this site today. The appeal "at the gateway of Jones Beach" (still seen today on a community place-name sign) was meant to attract vacationers for an extended stay on Long Island.

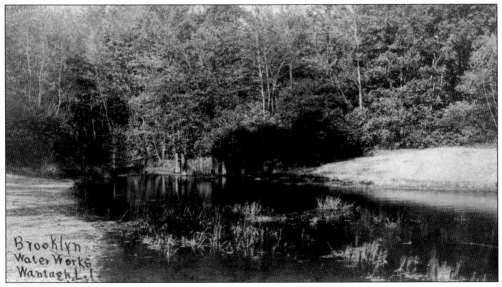

Watershed properties like this in Wantagh were acquired when Brooklyn was an independent city in 1870 to furnish water for its residents. After Brooklyn became part of Greater New York, it no longer needed them. Seeing this, Moses had the city transfer 2,200 acres of these properties to the state to obtain the necessary right-of-ways to different state parks throughout Long Island. On this bucolic watershed, the future Wantagh State Parkway was built leading straight to Jones Beach.

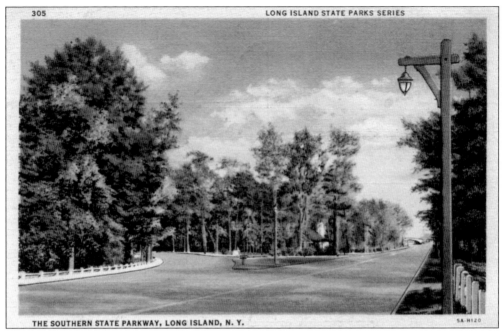

THE SOUTHERN STATE PARKWAY, LONG ISLAND, N. Y. SA-H120

The Southern State Parkway's purpose was to help bring motorists to Jones Beach. The vistas it provided were a source of pride to the Long Island State Park Commission. This mid-century postcard effuses: "This view of the Southern State Parkway where the road branches to join the Jones Beach Causeway is perhaps the most beautiful part of one of the most beautiful parkways in the State of New York." Work on the Southern State Parkway began in 1925 and ended in 1962.

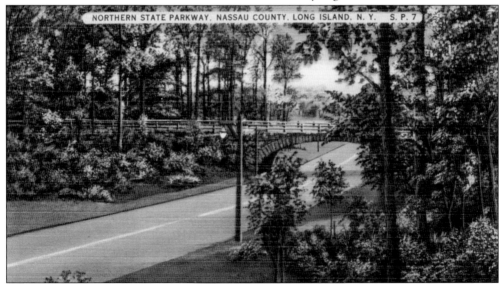

NORTHERN STATE PARKWAY, NASSAU COUNTY, LONG ISLAND, N. Y. S. P. 7

While aesthetically pleasing, the overpasses along Long Island's parkways are to some problematic. Since their clearances were built with automobiles in mind and disregarded larger vehicles like buses, some—notably Robert Moses's biographer Robert Caro—contend that the overpasses were agents of racial exclusion, since buses were then largely patronized by minorities. This postcard does not specify where on the Northern State Parkway this is. Adding to the uncertainty is an identical postcard referring to this as the Southern State Parkway.

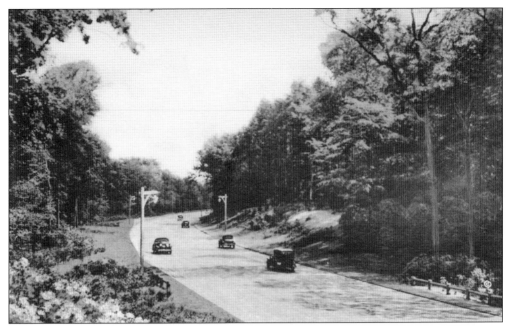

Here, with motorists driving at a leisurely pace, Moses's best plans are realized, if only for the time being. Given the pace of today's vehicles on Long Island's parkways, one is nostalgic for this kind of tranquil scene, suggestive of a trip in the English countryside. This parkway, while unspecified on the postcard, still shows Moses-inspired refinements in the wooden lampposts, which blend well with the surrounding forestry.

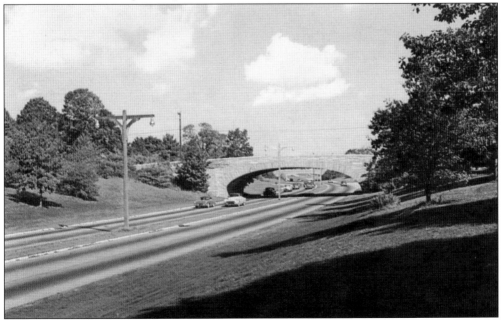

A later view of the Northern State Parkway shows automobiles emerging from one of its underpasses. This image was presumably taken in early autumn during the early 1950s. While not as verdant as the prior postcard image, this view still conveys the ease in which automobiles travelled on Moses's parkways.

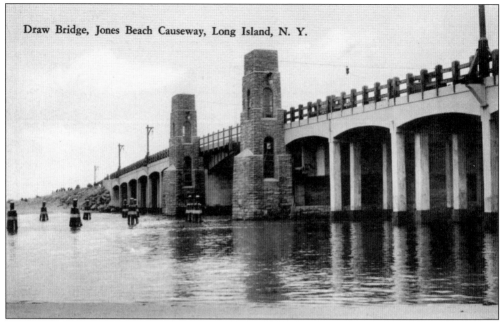

Draw Bridge, Jones Beach Causeway, Long Island, N. Y.

This Albertype postcard—published, curiously enough, by M.F. Savage of High Hill Beach—depicts the 520-foot drawbridge (a bascule bridge) Moses had built over Goose Creek on the Jones Beach Causeway for the last leg of the journey to Jones Beach. In keeping with the handsome appearance of his parkways, this bridge also benefited from his attention to detail, specifically in the Neo-Gothic turrets that served as the bridge's lookouts.

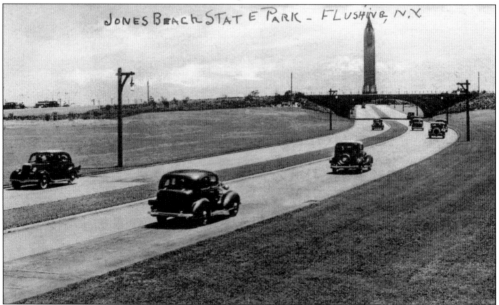

JONES BEACH STATE PARK - FLUSHING, N.Y.

Clearly, the sender of this postcard was mistaken to think that Jones Beach was in Flushing. Yet the image clearly shows the iconic Jones Beach Water Tower beckoning motorists to spend their day at the beach. Once drivers approached the traffic circle near the water tower, then bore immediately right, they came to Parking Field 4 behind the Central Mall. After parking their cars, what they did next was up to them. Such was the excitement behind a day at Jones Beach.

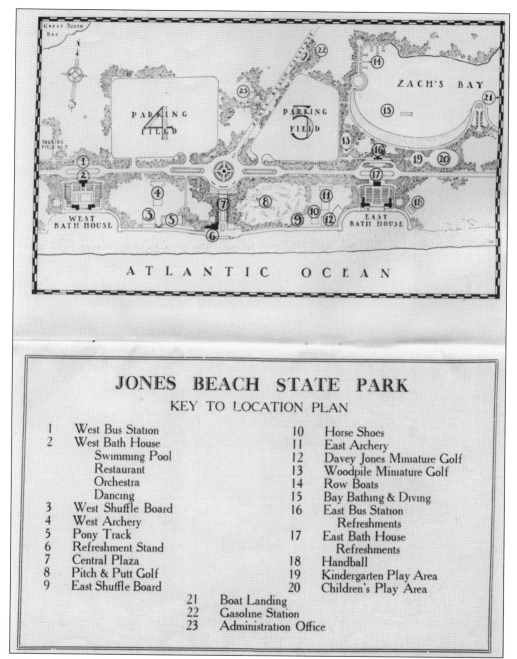

JONES BEACH STATE PARK
KEY TO LOCATION PLAN

1	West Bus Station	10	Horse Shoes
2	West Bath House	11	East Archery
	Swimming Pool	12	Davey Jones Miniature Golf
	Restaurant	13	Woodpile Miniature Golf
	Orchestra	14	Row Boats
	Dancing	15	Bay Bathing & Diving
3	West Shuffle Board	16	East Bus Station
4	West Archery		Refreshments
5	Pony Track	17	East Bath House
6	Refreshment Stand		Refreshments
7	Central Plaza	18	Handball
8	Pitch & Putt Golf	19	Kindergarten Play Area
9	East Shuffle Board	20	Children's Play Area
		21	Boat Landing
		22	Gasoline Station
		23	Administration Office

This c. 1931 schematic illustrates the variety of activities present at Jones Beach. Absent is the dizzying array of mechanical rides, cheap carnival games, freak shows, and so on found at the outskirts of Brooklyn. Moses was vehemently opposed to these, while convinced that people would benefit from—and thus naturally gravitate towards—more "wholesome" forms of recreation at Jones Beach, like pitch and putt golf, horseshoes, and archery, among many others.

"Follow the seahorse to Jones Beach State Park!" Jones Beach's beloved mascot (or coat of arms) was put to good use, appearing on such sundry places as directional road signs along Long Island's parkways, a mosaic in front of the East Bathhouse, stenciled on the park's trash cans, and such ephemera as matchbook covers and sugar wrappers. As author John Hanc acknowledges, the seahorse "was one of the first of many exquisite little touches that would become part of the Jones Beach signature." This luggage decal, however, is a reissue (for an original, see page 105).

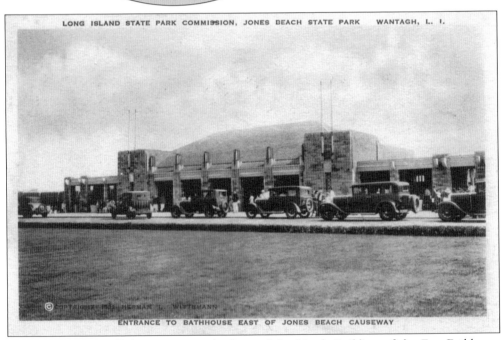

ENTRANCE TO BATHHOUSE EAST OF JONES BEACH CAUSEWAY

Here, drivers drop off their passengers in front of the North Building of the East Bathhouse before parking their cars, which, given the beach's instant popularity, could have been quite time-consuming. The East Bathhouse was the only pavilion present when the beach opened in 1929. Not long after, it was decided that another bathhouse was needed. The sender, Dot, gives her own reason for this: "Water is swell down at this beach." Note how the LISPC approved of this image by bearing its name on top.

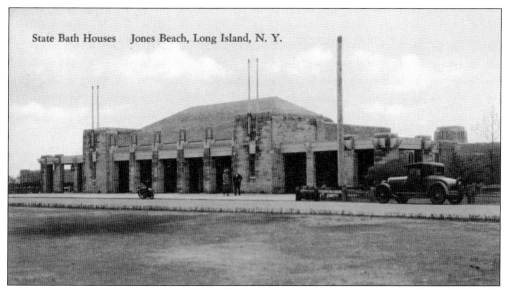

State Bath Houses Jones Beach, Long Island, N. Y.

With an identical perspective of the East Bathhouse as in the previous image, this postcard was published by M.F. Savage of High Hill. Apparently, the postcard business was a lucrative one, and Jones Beach turned out to be a particularly good subject. Given that the prior image was copyrighted by the LISPC, and that Jones Beach was state-run, it is not known how Moses would have reacted to what might have been unauthorized photographs capitalizing on Jones Beach, but one can imagine that he would not be happy about it.

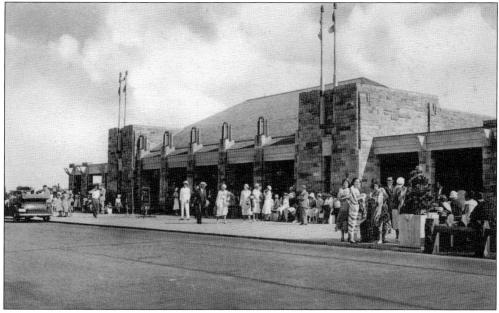

And so, the people came—and did they ever. The stylish dress of those in this c. 1932 postcard depicting the North Building of the East Bathhouse (labeled on the back of this postcard as "Bath House no. 1") suggests they could be mistaken for genteel members of an exclusive club waiting for their limousines to arrive. To the delight of the LISPC, which published this postcard, these guests project an impression that Jones Beach is, in the existing realm of public beaches, a cut above the norm.

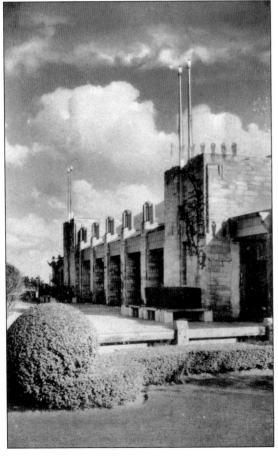

Park attendants tend to the grounds at the East Bathhouse. According to the state's *Historic Structures and Cultural Landscape Report* (2013), Jones Beach's famed landscaping was based on the elegant parterre garden style. Conceived during the Renaissance, parterre design is known for its open spaces of symmetrical design bordered by finely pruned hedges. Pathways are lined with plantings of different species of shrubbery, which is preferred over flowers. Such sophistication set Jones Beach apart from other public beaches.

Another view of the East Bathhouse before the Jones Beach Causeway shows its well-trimmed shrubbery and simple yet attractive benches. Note its entrance to the right. Moses's selection of the best building material for his bathhouses—Barbizon brick and Ohio sandstone, materials not readily available anymore—and the emphasis on neat landscaping reflect his belief that nothing is too good for the people of New York.

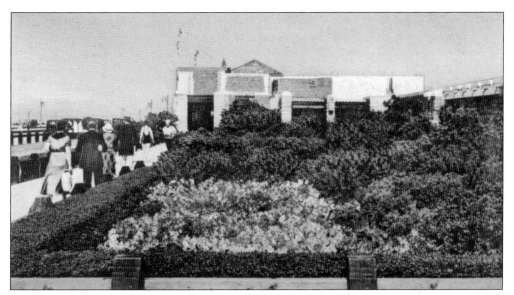

Before Jones Beach, the idea of beautiful floral landscaping at public beaches was never considered. Yet here it is, beside the West Bathhouse as it faces the causeway. Such a touch could have been meant to suit the tastes of the respectably dressed people making their way to the beach. Adele wrote to her friend Ruth in Pomona, California, that she was "spending a couple of days here—lovely place."

While fanciful, this c. 1950s Tomlin postcard shows the fulfillment of Long Island as the "vacation paradise" that Robert Moses envisioned. It was natural that, as the city's backyard, Long Island would be developed to meet the recreational needs of New Yorkers. On this postcard, its beachfronts are well represented, including Jones Beach, but all in the greater context of the worthwhile activities that Long Island held in store. Also evident are the arterial routes towards desired destinations. This postcard reflects what was widely seen as Long Island meeting a bright future.

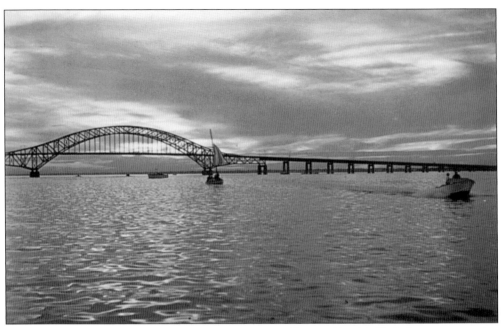

JONES BEACH STATE PARK

TIME TABLE

SUMMER 1937
STARTING MAY 30

BUSES
OPERATING
FROM

Flushing — Central Terminal Building
Floral Park — Tyson Avenue and Jericho Turnpike
New Hyde Park — Lakeville Road, Jericho Turnpike
Mineola — Court House
Hempstead — Main and Fulton Streets

NORTH SHORE BUS CO., Inc.
Telephone — FLushing 9-8100

Featured in this Kodachrome postcard of a sunset is the graceful silhouette of the Fire Island Inlet Bridge, completed in 1951 but modified since to accommodate northern and southern bound traffic. Located east of Jones Beach, the roadway (today's Robert Moses Causeway) was another way to make Jones Beach accessible, allowing motorists from both directions to head towards it via Ocean Parkway. Motorists heading farther north, however, can reach the Southern State Parkway westbound or the Sagtikos Parkway to the east.

Correctly foreseeing that car travel was what the future held, Robert Moses felt that motorists were the ideal patrons for Jones Beach. Buses, while clearly secondary in his line of thinking, nevertheless played their role, dutifully transporting those who did not own a car. This handy bus schedule from the North Shore Bus Company revealed the time it took to get from Flushing, Queens, to Jones Beach (there were 19 stops in between). On weekdays, an adult round-trip fare was $1; on weekends, it was raised to $1.25.

Three

BOARDWALK AND BATHHOUSES

If Jones Beach's bathhouses represent the pleasure of summer, its boardwalk welcomes visitors to walk it regardless of season. The mile-long, 40-foot-wide esplanade runs parallel to the beach until it bends towards each bathhouse's plaza, where it then branches towards their respective beach pavilions at the end. Here, its width is narrower and pleasantly intimate.

With their architecture designed to elevate the public beach experience, the East and West Bathhouses were unlike anything that preceded them. In 1929, the East Bathhouse—with its stubby turrets indicating time and tide—met the public in a way that "rose out of the landscape . . . like a force of nature," according to architecture and design professor Matthew Deckery. Inside were 10,000 lockers, and it also boasted a cafeteria and outdoor dining area, first-aid station, and beach shop. Two pools were installed in 1967.

The Moorish-styled West Bathhouse (whose whimsical appearance Robert Moses did not fully take to) opened in 1930 to meet the uptick in beach attendance. Along with two saltwater pools (which also facilitated night swimming), there were solaria offering protection for nude sunbathers, tea terraces, a private banquet hall, and the Marine Dining Room to serve the public. Its two pools hosted water ballets, swim competitions, and diving acts. In accord with Moses's love of swimming, free swimming classes were instituted; in 1935, a thousand youngsters learned how to swim with lessons the staff conducted. During the war years, solemn flag ceremonies were instituted as a show of patriotism, though not without some complications. As historian Julian Denton Smith observed:

> [At] six o'clock, a taped version of the event at The Mall and entirely orderly and practical. The pool area became silent and everyone stood at attention and many saluted. The only uncertainty of conduct occurred at the dressing rooms. . . . Anyone caught in the showers at the playing of the National Anthem wondered how to act—do you salute, do you cover up, do you go on as though you were completely deaf, do you get ready to pledge allegiance, what do you do!

Indeed, but the human element was undeniably part of what Jones Beach was all about.

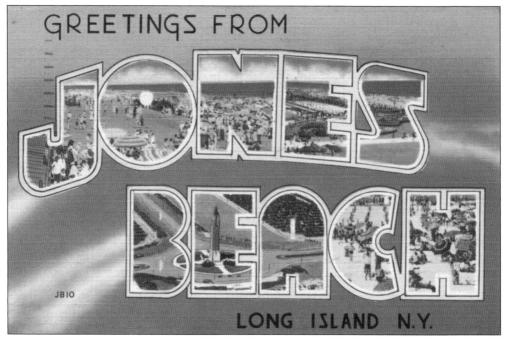

GREETINGS FROM JONES BEACH

JB10

LONG ISLAND N.Y.

These two "Large Letter" postcards from the Tomlin Art Company have an obvious message: for the writers to be (or have been) at Jones Beach (an approach similar to those from High Hill Beach on page 17, though without alluding to the risqué for reasons of propriety). Both postcards were meant to give readers the impression that Jones Beach was a must-see destination, a place that had to be experienced to be believed, and a vacationland par excellence. Given their graphics, it would be hard to imagine the postcard writer in anything but a cheerful mood. Elements of Jones Beach are placed in the lettering, something Tomlin cards did for other noteworthy destinations as well.

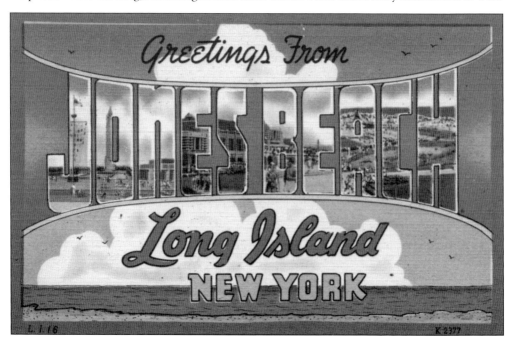

Greetings From JONES BEACH Long Island NEW YORK

L. I. 6

K-2377

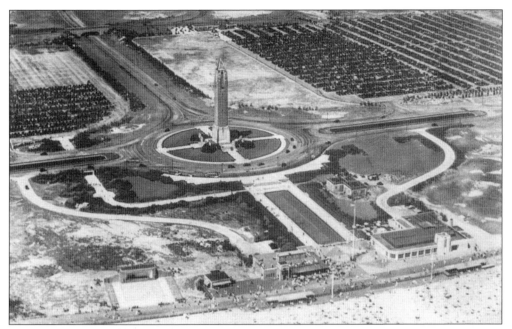

Many early Jones Beach postcards consisted of aerial photographs such as this. Given the novelty of air travel, it is easy to see why: it signified a bright future lay ahead (particularly important during the Depression). The composition present in this overhead perspective makes for a striking postcard. If during the 1930s, one had not stepped foot in an airport, let alone boarded a plane, one stood to be impressed with what the state accomplished at Jones Beach as seen in this fine image.

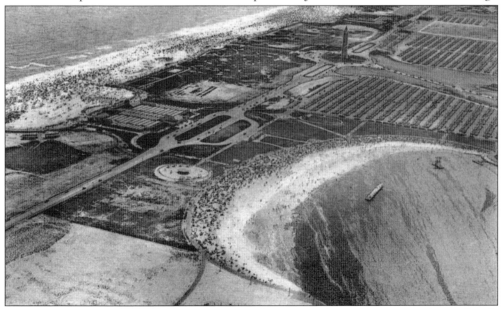

This exhilarating aerial photograph with a view facing west shows the vastness of Jones Beach. The Atlantic Ocean is in the upper left, while Zachs Bay sits in the foreground. Cars are parked in tidy columns, while beachgoers are reduced to specks. Ocean Parkway runs diagonally toward the water tower, which is hardly discernible here. Despite the effort it took to point a camera from this great height and distance, this extraordinary image illustrates the grandeur of Jones Beach.

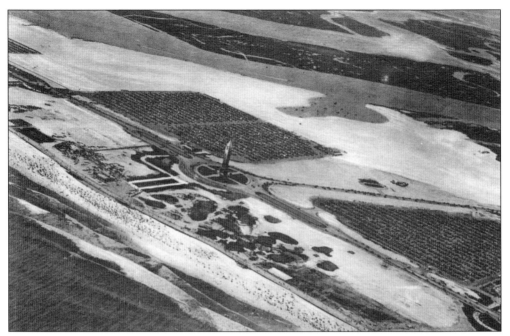

Yet another electrifying view, taken in 1932, draws attention to the packed parking fields behind the water tower. While the landscape in the background looks characterless, one can gather that this photograph was taken during the peak hours of a summer day, making it a great publicity shot.

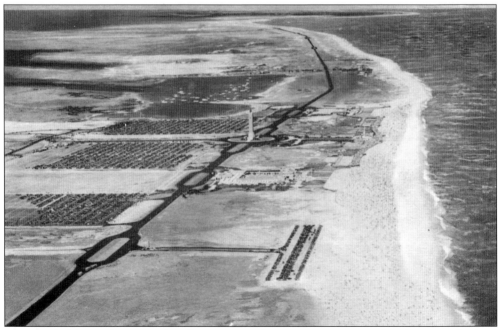

This aerial photograph captures how limitless the Atlantic Ocean appears to be. The view is looking east, and again, Jones Beach's parking fields are filled nearly to capacity. The west end of the beach is in the foreground, and slightly to the back is the West Bathhouse. While the water tower sticks out, a sense of movement comes with the Ocean Parkway running parallel to the shoreline.

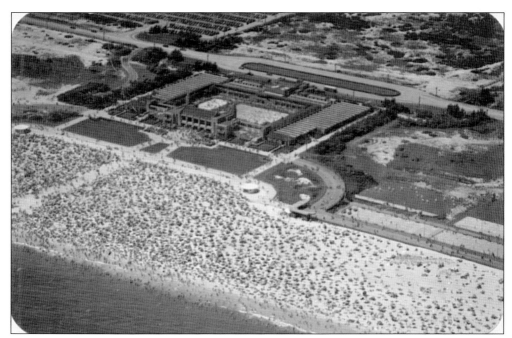

A latter-day aerial postcard features the West Bathhouse and its pools. Notice how the boardwalk curves toward its plaza. To the bathhouse's right are shuffleboard courts and archery ranges (the targets appear as barely distinguishable dots). A throng of ocean bathers make up the bottom third of this photograph.

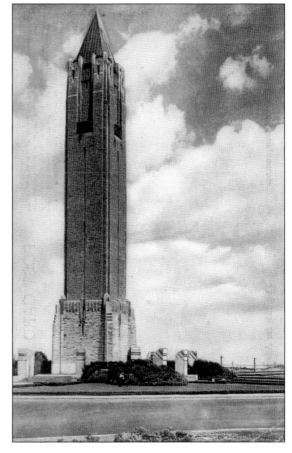

As a world-renowned landmark, the Jones Beach Water Tower stands tall at the intersection of the Jones Beach Causeway and Ocean Parkway. In this postcard image, one can see how Robert Moses's careful attention to architectural detail produced a dignified public utility. As for its function, one contemporary postcard outlined: "This structure of stone, steel and brick is approximately 200 feet in height and holds 320,000 gallons of fresh water." But one could make the argument that the water towers does nothing better than signify a fun day at the beach.

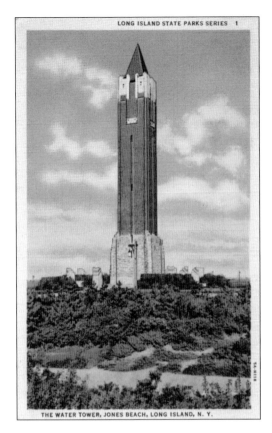

THE WATER TOWER, JONES BEACH, LONG ISLAND, N. Y.

This linen postcard, apparently the first in the Long Island State Park Series for this postcard publisher, shows the water tower amid a lush landscape. It seems to suggest that the water tower is approachable by foot, but that is not the case. The water tower actually sits on an island isolated from the rest of the park and is surrounded by Ocean Parkway. While an admirable piece of functional architecture, it is best appreciated from a distance.

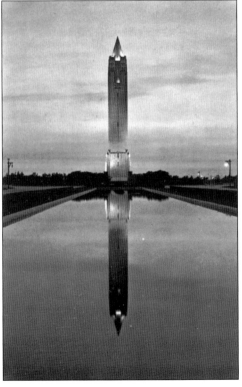

As the water tower was a popular subject, creative photographers tried to capture its essence in a myriad of ways. In this c. 1949 photo postcard, its reflection in the water at the median of the Jones Beach Causeway presents an arresting image. Lending to this picture's dreamlike effect is that it was taken during twilight or possibly dawn. The moat in front has since been covered up to facilitate the widening of the causeway.

This fascinating portrait of the water tower at night reveals the extent of Moses's aesthetic sense. After rejecting the idea of building a lighthouse on this site, Moses settled on a structure inspired by Venice's St. Mark's Campanile. This frustrated state lawmakers, in charge of allocating money for Jones Beach's construction; they felt a conventional water tower was good enough. (It is said that Benito Mussolini sent his architects to Jones Beach to gather ideas for a similar beachfront park along the Adriatic or Mediterranean Sea.)

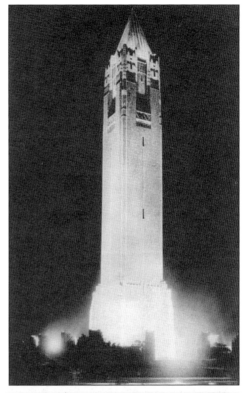

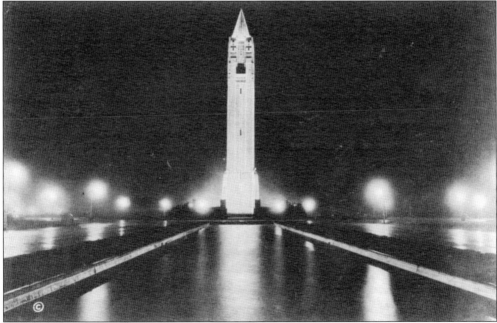

A wider night view shows the water tower awash in flood- and beacon lights. Such illumination ensured that the water tower could be seen more than 25 miles away, just like on the clearest of days. What is depicted here must have been a stunning sight; it certainly made for a stunning postcard—and another clever way to depict Jones Beach.

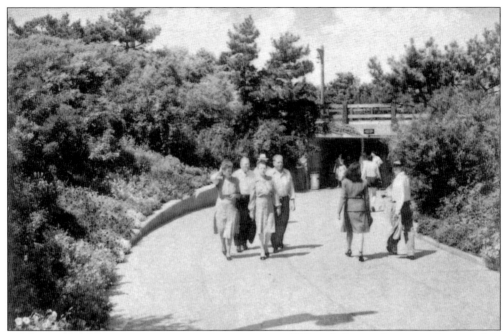

This early image shows people emerging from the dark of the underpass towards the Central Mall. Their excitement is mounting: they made it, the beach is in sight, and their day to relax is all but guaranteed. This postcard perspective was popular enough to be repeated in later-year postcards.

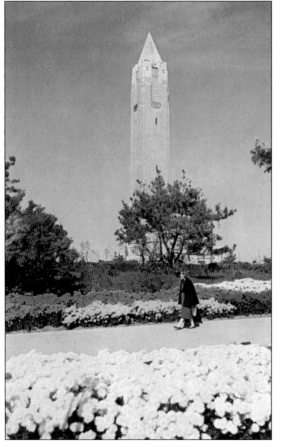

In this postcard, the water tower serves as a backdrop for another pleasant aspect of Jones Beach: its floral paths along the Central Mall as it leads to the boardwalk. It is fall, and a solitary walker is seen admiring the chrysanthemums in full bloom.

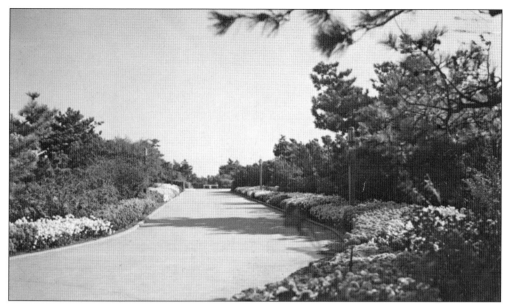

With no human activity present, this postcard (labeled *Fall Chrysanthemum Display*) gives its receiver a chance to pause and reflect on the sender and what he or she might be up to. It is the kind of picture that could enrich a personal message. In their own way, the wispy branches in the foreground lend to the contemplative mood.

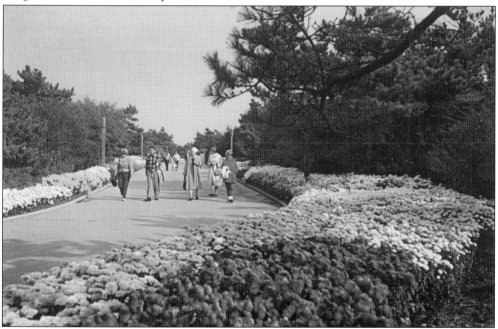

Note that this postcard, stamped at the end of August 1967, shares a perspective with the previous image. Sender Irene was quite the weekend tripper. She relates that she went to the Palisades amusement park in New Jersey the day before and that she was now spending time swimming "over here" at Jones Beach. One can only assume Irene enjoyed herself but was also resigned to the fact that all good things come to an end, for she finishes her message simply with, "Tomorrow back to work."

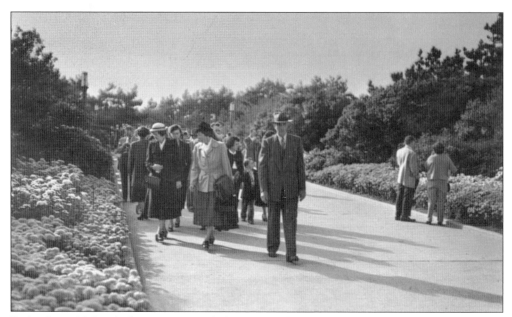

Seeing how this band of visitors is attired, this autumnal scene (captured on Kodachrome) touches on the resourcefulness of LISPC officials and how seriously they were committed to ensuring that people had a pleasant time at Jones Beach no matter the season. After all, swimming was feasible only three months of the year. But having the park's paths lined with vibrant-colored flowers was an effective and low-cost way to welcome guests when sand and surf were not an option.

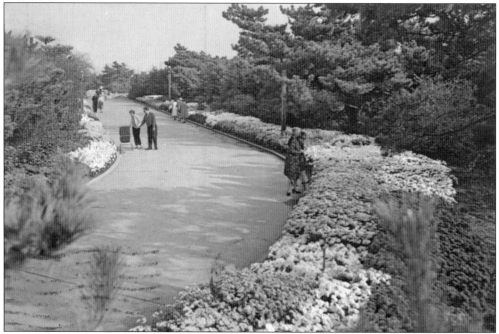

In this postcard, dated June 23, "Uncle Charlie" says that he came to Jones Beach for lunch and that he "had a very nice time." He goes on to say that he was also surprised at the number of people on the beach. Only he could explain why he chose to convey his message, written at the start of summer, on a postcard with an autumnal theme.

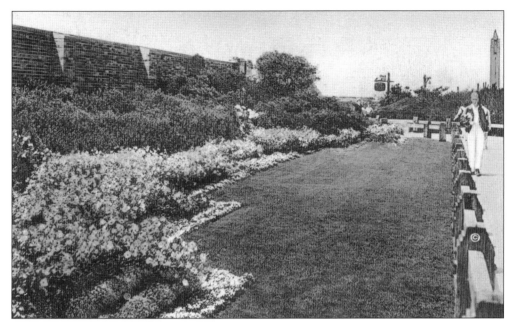

This older watercolor postcard shows some closely cut turf and a mass of purple florets lined along the length of the East Bathhouse in an alternate route towards the beach. From this, one sees the emphasis placed on Jones Beach's appearance. In the distance is a park sign with a silhouetted motif, another fine detail unique to Jones Beach. More on these signs can be found on page 98.

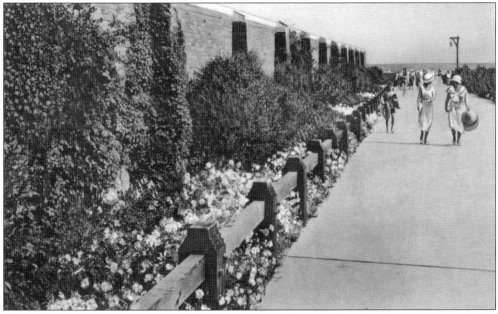

This is a similar depiction as that in the previous postcard, except that here flowers are seen lining the outer wall of the West Bathhouse in yet another route to the beach. However, contrast the two women with those at High Hill Beach on page 22. Judging by their trendy apparel, one can see how much social change has taken place in the span of just three decades. Since Jones Beach was presented to the public as innovative, it was only appropriate to show that it embraced modernity in every form.

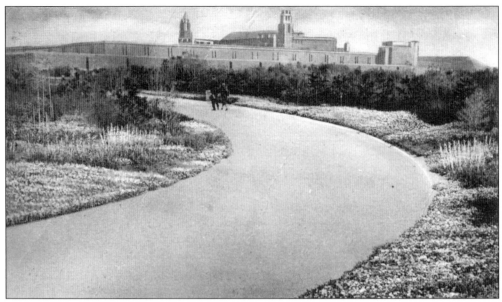

Depicted here is a winding path behind what appears to be more of a sketched version of the West Bathhouse (labeled on the back of this postcard "Bathhouse No. 2"). Here, too, among the greenery are flowers that border the path to the bathhouse. On the postcard's reverse, Maria expressed her satisfaction: "The cleanest & best place I ever stumbled into."

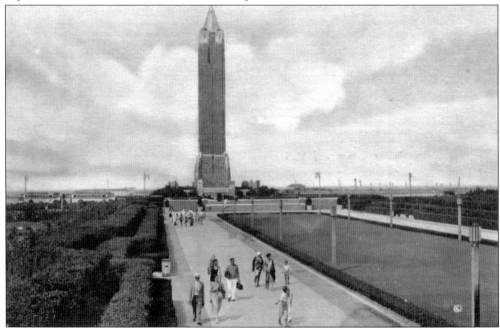

In this early photo postcard, people are emerging from the underpasses built so visitors would not have to cross the ever-busy parkway. They are making their way towards the Central Mall and eventually to the beach. The Central Mall is at the heart of the beach's layout and was based on parterre garden style (see page 36). Note the prevailing sense of order. The *Saturday Evening Post* offered the thoughts of one appreciative patron in 1941: "What you find at most public beaches is what you go to Jones Beach to avoid."

This linen postcard, printed approximately 10 years after the prior image, presents a condensed view of the Central Mall. More people are shown walking on it, and the water tower seems to loom higher than before. Despite the differences between the two images, of interest are the buses in the back, which seem to have dropped off their passengers. If one assumes that the well-dressed visitors on the Central Mall just disembarked, this postcard's underlying message that Jones Beach did in fact serve a wide clientele (even though Robert Moses preferred those who had their own cars).

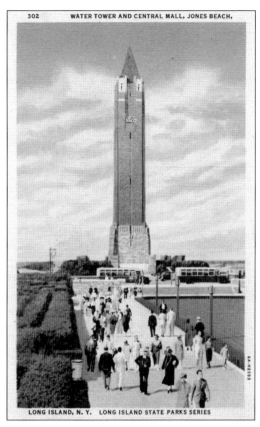

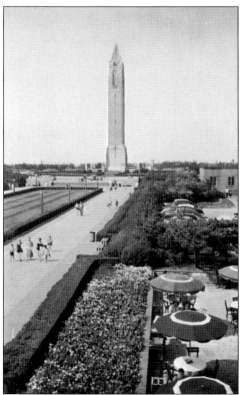

A later Kodachrome view shows the Central Mall, this time revealed in mid-afternoon and from the angle of the Tea Terrace, in the foreground to the right. Oversized umbrellas to the right shield patrons from the glare of the afternoon sun.

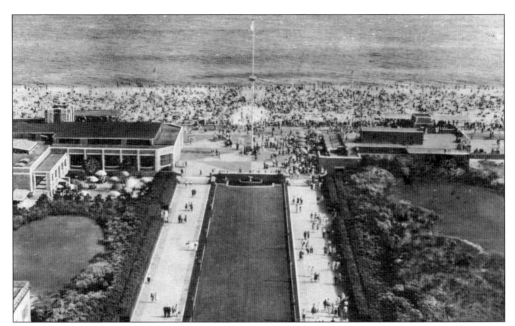

A heightened perspective of the Central Mall attempts to capture many elements of Jones Beach at once. Note the flagpole at the center of the top half of the image and the magnificent beach behind it.

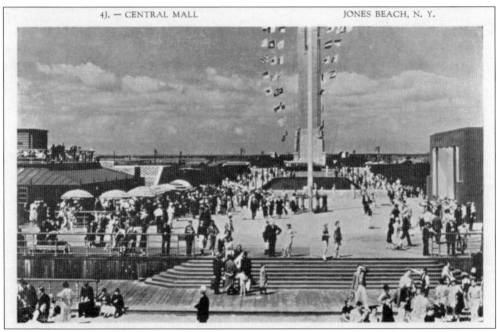

This vibrant image shows the glory that is Jones Beach on a sparkling summer day. Some people have just finished walking the length of the Central Mall leading toward the boardwalk. To the left is the West Mall Building (today a concession stand), and to the right is its counterpart, the Boardwalk Café/East Mall Building. The latter site would become the Boardwalk Restaurant. Both of these buildings were built in the Art Deco style of the period, and their presence lends to the symmetrical layout that was unique to Jones Beach.

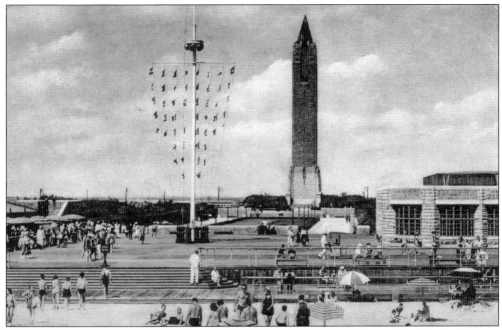

This image is quite similar to the preceding one, but the 90-foot-tall ship mast right before the boardwalk is more perceptible. Note the marine signal flags; today, these spell out "Jones Beach State Park" on one side and the admonition "Keep Your Park Neat" on the other, along with the current year. It is an ingenious way to convey an important message that was in keeping with Jones Beach's nautical theme, but it relies on people's willingness to make the effort to decipher it.

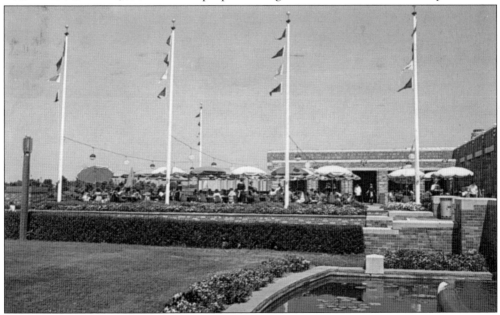

Behind the Boardwalk Café/East Mall Building, running parallel to the Central Mall, is this side view of the Tea Terrace's patio and large sun umbrellas. Notice the servers dressed in maid-like uniforms and a sweeper in the doorway who appears to be dressed like a porter. Such uniforms would not be used today, but then they helped to project Jones Beach's air of sophistication.

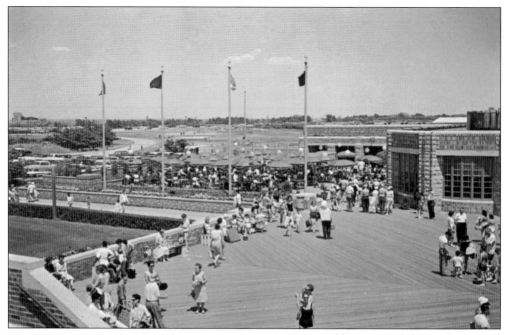

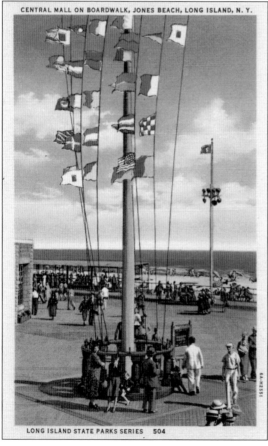

CENTRAL MALL ON BOARDWALK, JONES BEACH, LONG ISLAND, N. Y.

LONG ISLAND STATE PARKS SERIES 504

Presented here around the 1960s is a candid view taken at or around noon where the pedestrian walks at the Central Mall and the beach boardwalk meet. The Tea Terrace is shown with patrons being served. The original Boardwalk Café/East Mall Building is to the right, and the well-known pitch and putt golf course is in the distance.

A close-up of the bottom half of the ship's mast in the Central Mall shows the American flag and marine signal flags waving in a stiff breeze. While a little garish, the graphics of this linen postcard are typical of the kind produced in the late 1930s.

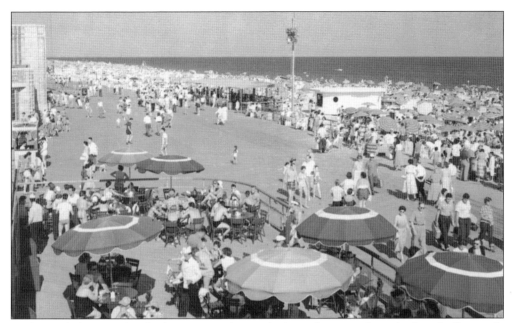

In this Kodachrome taken looking eastward on a glorious afternoon along the boardwalk, people are fully enjoying their day at the beach. In the foreground, the umbrellas are beside the West Mall Building (not shown), the first major building to be built on the boardwalk and Central Mall, initially publicized as a comfort station and refreshment stand. The Boardwalk Café/East Mall Building is barely visible to the left.

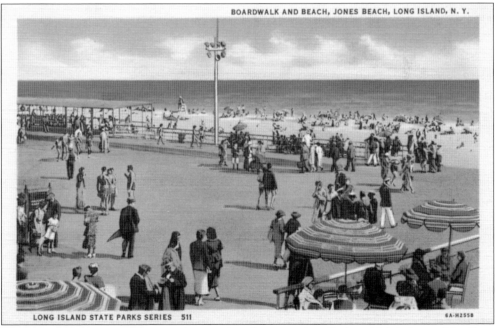

BOARDWALK AND BEACH, JONES BEACH, LONG ISLAND, N. Y.

LONG ISLAND STATE PARKS SERIES 511

6A-H2558

This similar view was taken more from within the Central Mall plaza. This is in an older linen postcard produced around the early 1940s. As is typical of the postcards of this era, its detail leaves something to be desired. On the other hand, it is quite colorful, a technique the postcard's manufacturer (Art-Colortone) used to help render a sweeping view.

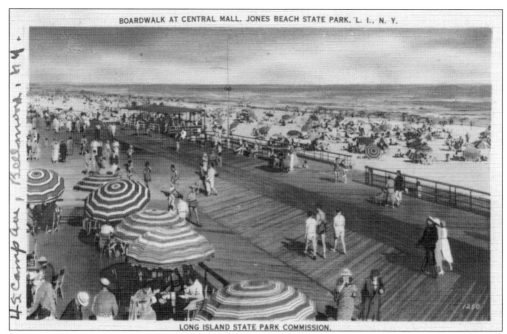

Still another view looking east along the boardwalk, again from the roof of the refreshment stand, this vibrantly hand-colored c. 1930s postcard was published by Metrocraft, based in Massachusetts. Unlike in the prior image, the wooden boardwalk is finely detailed. The umbrellas are colorized, but the postcard manufacturer seemed more interested in presenting an attractive image rather than one that was more realistic. Still, the beach crowd reflects a typical scene of Jones Beach.

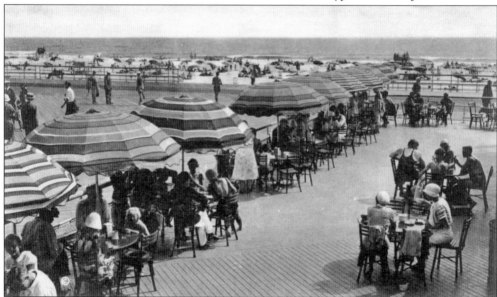

A candid shot, now facing west, shows the concession area (referred to as "Luncheon Terrace" on the back of this postcard) at the West Mall Building. This early real-photo postcard of patrons eating lunch or a snack along the boardwalk depicts the enjoyment some derived from seeing and being seen. Notice the women to the right in their 1930s dresses enjoying some people-watching and the burly man in a full-body bathing suit (whose back is to the camera) enjoying his company.

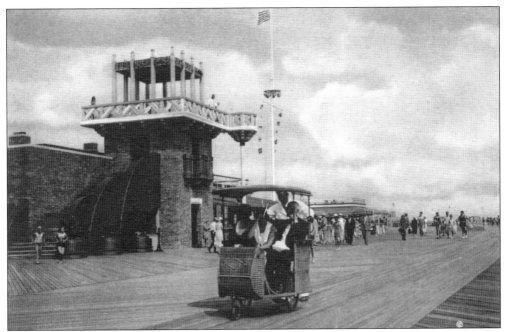

This postcard is a fine example of a postcard as a historical artifact. Prominently featured is the West Mall Building in its original state in 1930. Altered several times since then, it was originally an integral part of Jones Beach's nautical theme, as seen in the observation deck (a lookout tower) and cascading wave near the stairwell to the left, now both gone. For visitors not wishing to walk the boardwalk, the park furnished Atlantic City–like canopied carts as in the foreground for 50¢ an hour. Coney Island had such carts as well.

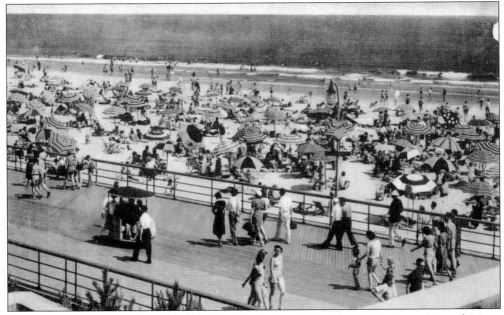

It does not get any better than this. Published by the Long Island State Park Commission, this is an early depiction of abundant activity found on the boardwalk and beach. Notice the canopied cart making headway amid the crowd, some dressed more conservatively than others.

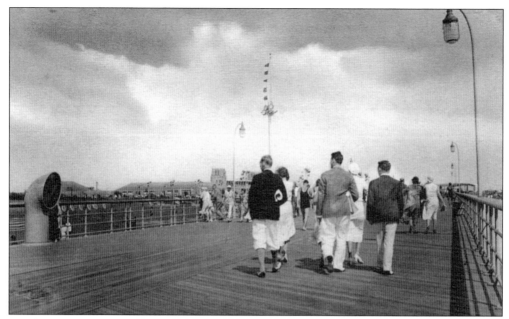

Another illustration, taken during off-season, shows that knickers were the rage. These visitors seem to be looking toward the east games area off to the left. Notice any trash can? Probably not: it was most likely housed in the ship's funnel to the left. Ship funnels were also used to store fire extinguishers in case of emergencies. It was a clever way to enforce an important safety measure. Notice too the ship–like lanterns hanging above.

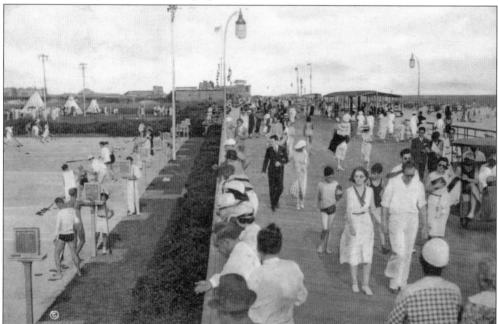

Another image of an active boardwalk scene, this postcard neatly divides boardwalk visitors in all manner of dress from shuffleboard players engaged in friendly competition. The Indian Village is to the upper left, and the boardwalk shelter is in the background. Yet another canopied cart is making its way through the crowd.

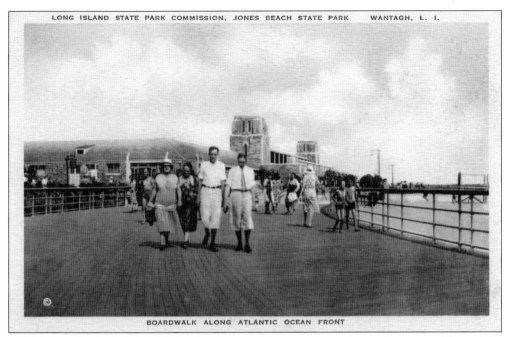

BOARDWALK ALONG ATLANTIC OCEAN FRONT

This 1931 Albertype postcard catches boardwalk patrons as they walk past the East Bathhouse. The camera is positioned at the last leg of the boardwalk before it sweeps into the bathhouse's plaza. The mahogany railing to the right runs the entire length of the boardwalk.

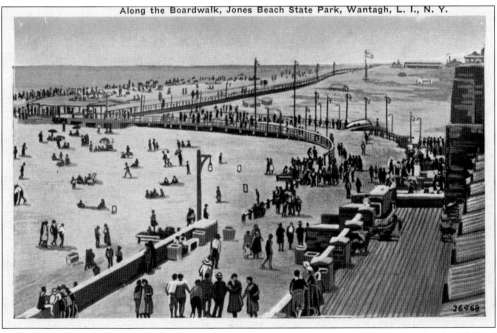

Along the Boardwalk, Jones Beach State Park, Wantagh, L. I., N. Y.

A bird's-eye view looking west from atop the East Bathhouse terrace shows the beach and boardwalk. While amateurish, this postcard shows the stretch of boardwalk as it leads towards the horizon.

59

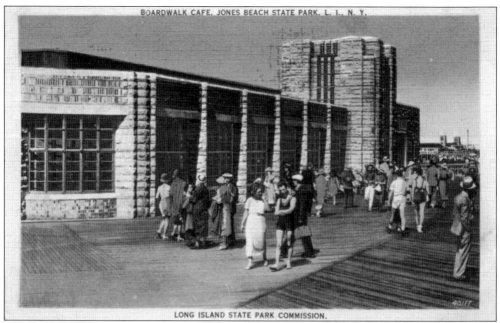

LONG ISLAND STATE PARK COMMISSION.

The image on this late 1930s–early 1940s linen postcard is a close-up of the Jones Beach Boardwalk Café/East Mall Building, a WPA project. Featured once again are people along the boardwalk. Note that, from a structural standpoint, the Boardwalk Café/East Mall Building vaguely resembles the East Bathhouse (a trace of which is seen in the background). This was intended to integrate the buildings with one another, fulfilling a key tenet of architectural harmony.

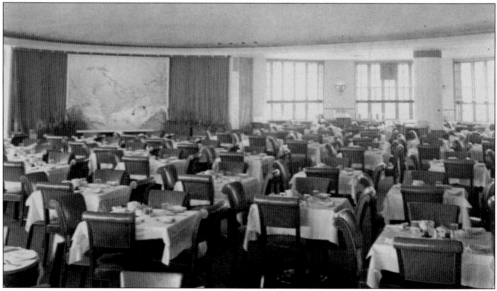

According to the state's *Historic Structures and Cultural Landscape Report* (2013), the Boardwalk Café first appeared "during a much more formal time at Jones Beach and America." Visitors spending the day at Jones Beach would make sure to also include dinner at the park's fine restaurants. This c. 1950 image shows the Boardwalk Café's elegant oval-shaped interior, its ornamental plastered cove ceiling, and its circular recessed dome with scalloped edges at its center. The Boardwalk Café was considered more formal than its counterpart, the Marine Dining Room (see page 73).

Imported HEINEKEN'S Beer—per bottle .40

COCKTAILS

JONES BEACH	.25	Daiquiri	.35
Dry or Sweet Martini	.25	Jack Rose	.35
Bronx	.25	Old Fashioned	.40
Orange Blossom	.25	Pink Lady	.40
Manhattan	.35	Clover Club	.40
Alexander	.35	Side Car	.45
White Lady	.40	Stinger	.50
Dubonnet	.35	Coffee	.50
Bacardi	.35	Carioca (West Indies style)	.50
		Ronrico (West Indies style)	.50

FIZZES and SOURS

Gin Rickey	.30	Tom Collins	.40
Gin Fizz	.35	Whiskey Sour	.40
Silver Fizz	.40	Sloe Gin	.40
Golden Fizz	.40	Planter's Punch	.50
Rum Sour	.40	Mint Julip	.50

DINNER—$1.50

Jumbo Shrimp Cocktail		Iced Canteloupe
Chilled Tomato Juice		Chopped Chicken Livers

❖

Hearts of Celery	Pickles	Queen Olives

❖

Jellied Consomme Madriline

Little Neck Clam Chowder	Consomme Egg Noodles

Choice of

Broiled Sword Fish Steak, Sauce Bearnaise
Baked Fresh Mackerel, Creole
Poached Kennebec Salmon, Sauce Hollandaise
Fried Deep Sea Scallops, Sauce Tartar
Whole Stuffed Squab Chicken, Giblet Gravy
Roast Prime Ribs of Beef au Jus
Broiled Virginia Ham Steak, Hawaiian Style
Braised Long Island Duckling, Apple Sauce
Fresh Garden Vegetable Dinner, Poached Egg
Assorted Cold Cuts, Potato Salad

❖

Rissole Potatoes or Candied Sweet Potatos	
Succotash	Young Diced Carrots

❖

Green Vegetable Salad, French Dressing

Choice of

Buttered Cookies	Rice Pudding	Fruit Jello

Gumpert's Chocolate or Butterscotch Pudding
Apple, Huckelberry or Pineapple Pie

Ice Cream	Raisin or Pound Cake

Old Fashioned Blueberry Short Cake

Coffee	Tea	Milk

Saturday, July 22, 1939

JOHNNY JOHNSON and His Orchestra Nightly

JONES BEACH TENTH ANNIVERSARY CELEBRATION
July 19 through July 23
Special Attraction at Marine Stadium
Wednesday 19 to Saturday, July 22 at 8:30 P. M.
Prices 25c, 40c. Reserved seats 55c, and a few at 75c.

To mark Jones Beach's 10th anniversary in 1939, the Boardwalk Café offered these selections along with its usual fare. Note the Jones Beach cocktail for a quarter, and that a dinner of swordfish, stuff squab, poached salmon, or Long Island duckling could be had for $1.50, dessert included.

Two successive phases of Jones Beach's development are seen from the beach in a study in contrast. Above is a profile of the Boardwalk Café/East Mall Building before it caught fire in 1964. Below is its successor, completed in 1967. Both show the architectural styles of their respective times. In the case of the latter, however, little attention was paid to the existing structures or what gave Jones Beach its original panache. Interestingly, separate postcard publishers used the same vantage point. Whether this was purposely done or a coincidence is not known.

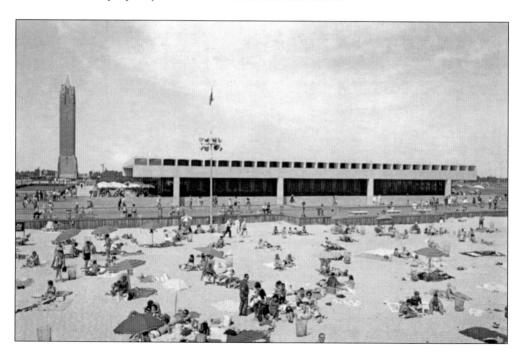

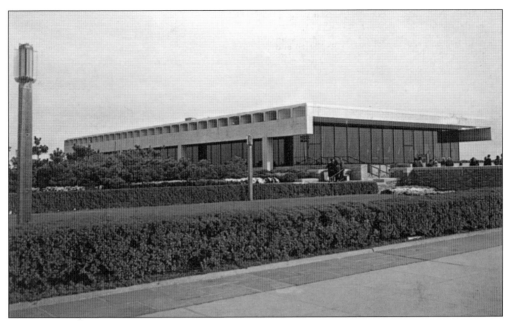

A fire destroyed the Boardwalk Café in 1964, and it was replaced three years later by this minor brutalist structure designed by Skidmore, Owings & Merrill. Rechristened the Boardwalk Restaurant, its design, while not overbearing, did not relate entirely well to the beach's original Art Deco scheme. Structural deficiencies would later surface and pose problems to the point that the Boardwalk Restaurant had to close. It was razed in 2004.

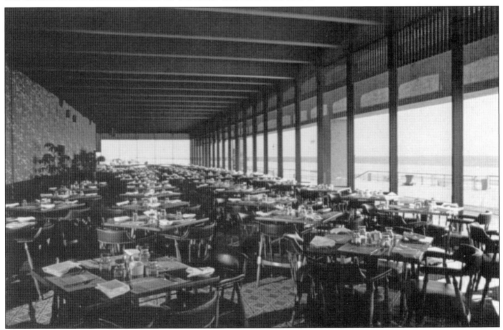

The interior of the new Boardwalk Restaurant is shown. Perhaps taking its cue from the earlier postcard of the Boardwalk Café, or the Marine Dining Room, the Jones Beach Catering Corporation at Jones Beach State Park felt that this rendering might attract customers. At least the captain's chairs hearken back to Jones Beach's original nautical theme.

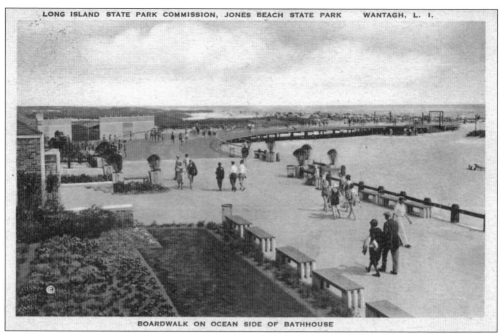

BOARDWALK ON OCEAN SIDE OF BATHHOUSE

This image was taken before the structure known today as the West Bathhouse was built. (The postcard was copyrighted in 1931.) Note that the parterre garden lawn at the front of the West Bathhouse in subsequent years is not present; instead, there is a neat row of benches. This is a telling view of Jones Beach before the West Bathhouse's completion.

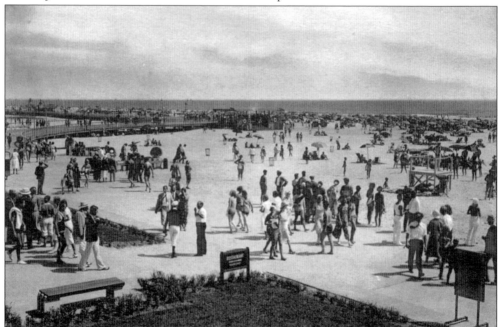

This c. 1932 postcard shows the plaza at the West Bathhouse. As with many postcards, there are many patrons depicted, arriving towards the bathhouse and along the shore on what looks to be a prime beach day. Notice the sign in the foreground pointing to a restaurant, most likely the Marine Dining Room.

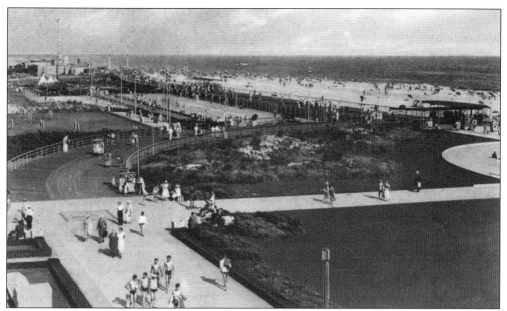

Another early view taken from a perch on the south side of the south building of the West Bathhouse gives a more encompassing view eastward. Note the west games area (the archery range in particular) and the boardwalk leading to the plaza. Notice also the canopied cart pushed along the curve of the boardwalk. On the back of this card, stamped in 1938, Edith lovingly writes: "We were here last night between daylight and dark and it truly was beautiful. Us [sic] would all love to see you when you can come. Rain checks included."

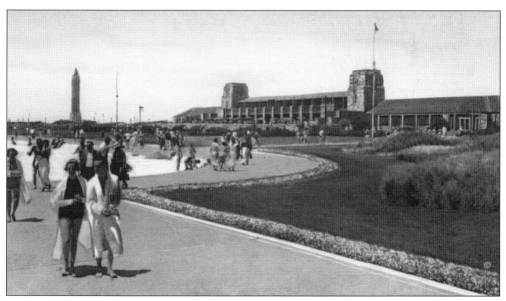

This watercolor postcard depicts beachgoers ambling past the East Bathhouse, which lies adjacent to Zachs Bay. One's eyes are drawn to the smart couple in the foreground looking like club members. When this postcard was issued during the early 1930s, the LISPC officials saw advantage in promoting Jones Beach's sophistication, impervious to the effects of the Depression. The flowers lining the edge of the lawn are an embellishment by the postcard manufacturer.

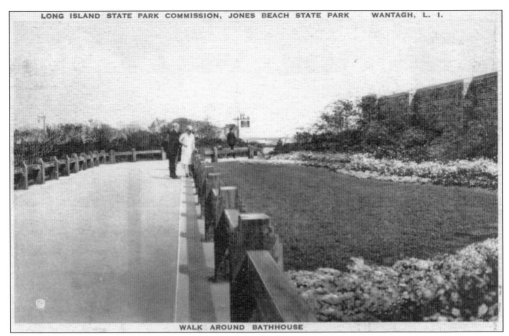

WALK AROUND BATHHOUSE

Though this candid image is harmless by itself, maybe it is too candid, raising a question over what kind of postcards the LISPC believed were fit for distribution. Unlike the modish couple seen earlier, here is an older couple in more conservative dress by the side of the East Bathhouse engaged in some small talk. Also depicted is a man with his back to the camera, fully dressed as well, who seems to be leaving the premises altogether. It all comes off as rather inconsequential.

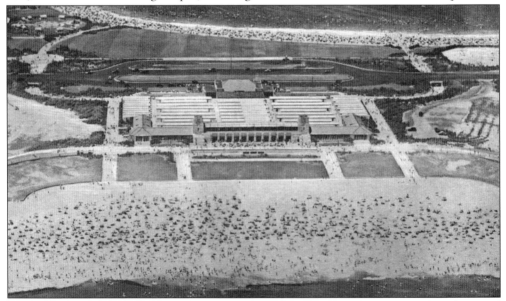

An aerial shot shows the East Bathhouse between the ocean and Zachs Bay. As with earlier aerial views, one gains a heady feel that only such a perspective can give. Behind the grand South Building (facing the beach) is the courtyard at the center, where the bathhouse's changing rooms, showers, and lockers were located. To add to its clubhouse-like exclusivity, the courtyard was out in the open, while its changing rooms were placed in cabana-styled buildings.

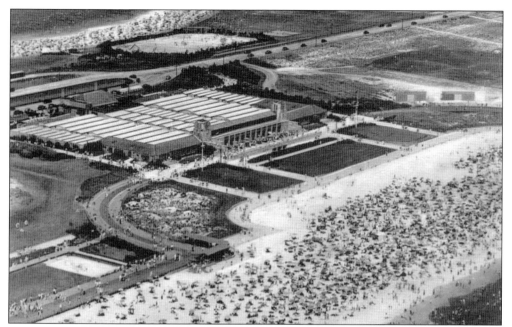

In another magnificent aerial view of the East Bathhouse, the beach has a greater portion of the picture. However, unlike in the previous image, there is a better view of the boardwalk towards its plaza. The east games area is to the left (the archery field barely visible), and cars are riding along Ocean Parkway.

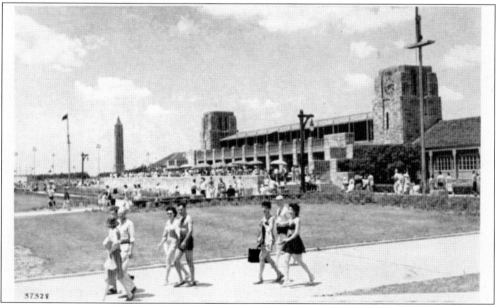

This candid view is of the East Bathhouse's South Building with the water tower in the distance. Done in the Art Deco style, the East Bathhouse, according to the *State Historic and Cultural Landscape Report*, "resembled a larger than life sandcastle rising out of the sand." The stubby towers and rustic masonry lend an air of timelessness. The west tower gave the time and the east tower the tide. Note the awnings on its second floor and the terrace beneath it with tables for outdoor dining; in the early days, the canvas of the umbrellas and the awnings matched.

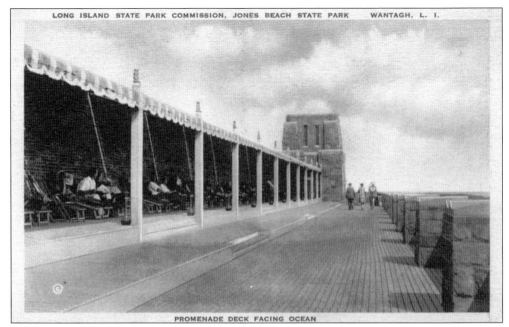

PROMENADE DECK FACING OCEAN

Here is a little-known view of the East Bathhouse's second-floor terrace. Featured are the awnings for patrons who wanted to relax on lounge chairs in the shade while taking in the sea air. This scene is reminiscent of the Sportsmens Hotel (see page 20), with visitors seated under its canopy relaxing in much the same way.

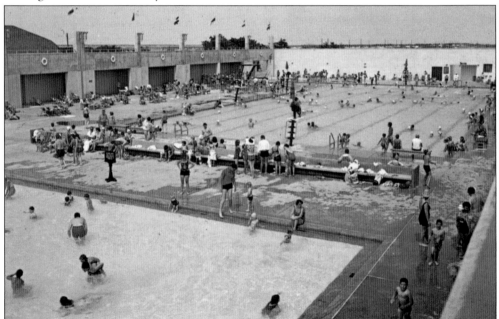

Initially, the East Bathhouse did not have a swimming pool. This changed in the latter half of the 1960s, when its existing configuration was drastically altered. It was timely enough, as the bathhouse's changing areas and some other parts were now starting to fall into disrepair. These areas made way for a new courtyard and two freshwater pools, as featured in this Kodachrome. New changing areas were installed on both sides of the bathhouse.

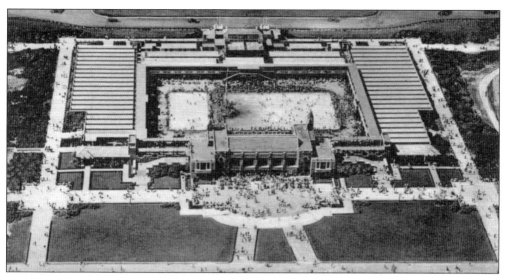

This aerial view of the West Bathhouse is from about the same elevation as that of the East Bathhouse (see page 66). A Beaux-Arts pile with Art Deco motifs, the bathhouse had a palatial look due to its stonework facade, upraised towers—in contrast to the stubby ones at the East Bathhouse—terraces with battlements, and fabric awnings. Notice the South Building in front and pools; restrooms were to the side. The childish rendering of cars traversing Ocean Parkway seems unnecessary.

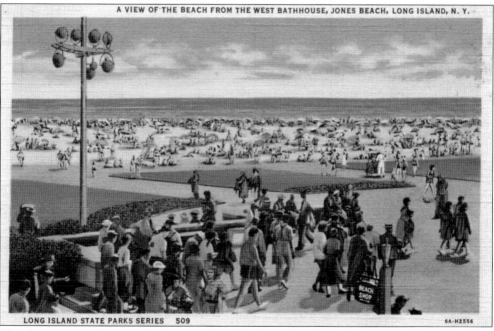

A VIEW OF THE BEACH FROM THE WEST BATHHOUSE, JONES BEACH, LONG ISLAND, N. Y.

LONG ISLAND STATE PARKS SERIES 509 6A-H2556

This linen postcard shows the boardwalk with people heading towards the right of the West Bathhouse. Typical of postcards printed in the late 1930s or early 1940s, it is a scene without much detail or even a frame of reference (and it seems like a drawing more suitable for a children's book). Making this scene more awkward are the many subjects walking with their backs to the viewer, which could have been done to avoid potential lawsuits from anyone who did not give formal permission to the postcard's publisher to use his or her likeness.

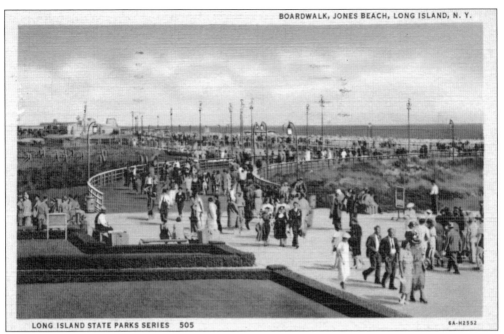

LONG ISLAND STATE PARKS SERIES 505

6A-H2552

A linen postcard closely related to the one before shows people arriving at the West Bathhouse's plaza. Again, the details are largely indistinguishable, but at least here there is a credible attempt to render a view of the expanse of the boardwalk, the parterre lawn in front of the bathhouse, and the archery range at the west games area to the left.

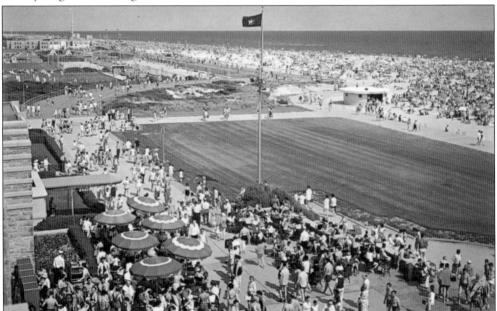

A view with the same vantage point as in the previous postcard, if a bit farther to the west, this Kodachrome clearly shows the staggering number of beachgoers that arrived at Jones Beach during the 1950s. Realistic depictions such as this led to the decline of linen postcards. Without question, this image depicts Jones Beach as a public beach par excellence. The state flag of New York is waving in the foreground.

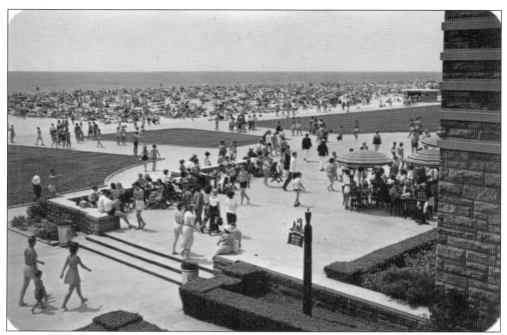

A close-up of the eastern corner of the West Bathhouse plaza includes a couple and their child making their way there. Note the silhouetted sign pointing to the beach shop where, among other things, postcards were sold. The beach's vibrant spirit is obvious.

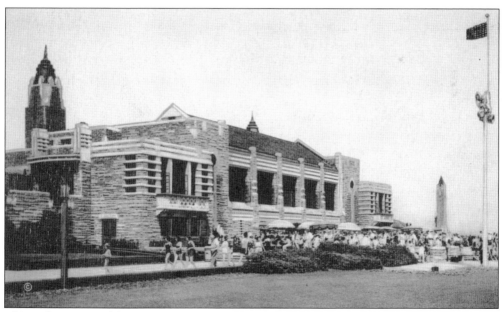

This early picture of the south side of the West Bathhouse (one of many such portraits over the years) captures it as the glorious building it was. The structure was designed by Herbert Mangoon, and it cornerstone was laid by Gov. Franklin D. Roosevelt in 1930. Its architecture offered the right amount of fantasy for visitors looking to take their minds off things. Like the East Bathhouse, it underwent changes over time, although a restoration effort took place in 2009. Note the Union Jack to the right, a nautical touch.

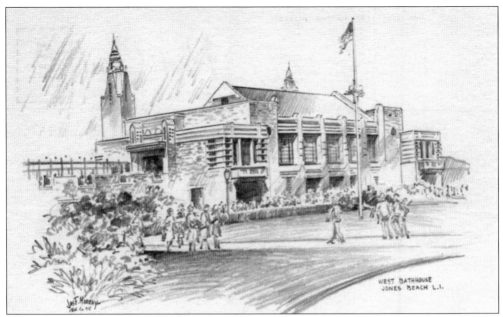

While a shift from the traditional photo postcard portrait, this rendering of West Bathhouse nevertheless has full membership in the Jones Beach postcard family.

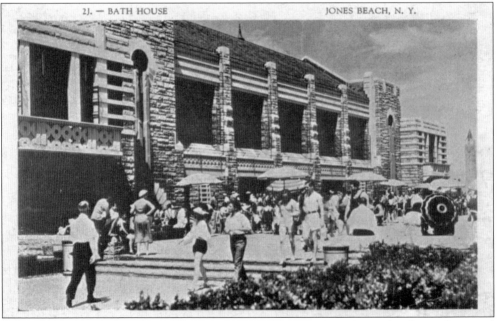

This c. 1940s photographic detail of the West Bathhouse's plaza shows the fine architectural elements that made the bathhouse pleasant to look at. Note the bay windows and the wide bands of cast stone trim that run across, along with the symmetrical pavilions, balconies, towers, and single-story wings. These features make up the West Bathhouse's palatial appearance. Yet for all this, people are shown perfectly at ease in its presence.

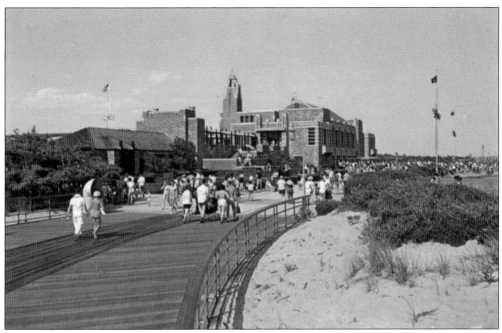

Facing east in the late afternoon, this is a different take of the boardwalk as it winds towards the West Bathhouse. The polished mahogany railing has since been replaced by an aluminum one.

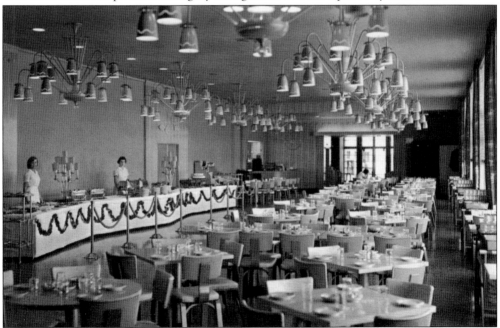

This is the Marine Dining Room inside the West Bathhouse around the 1950s with servers before a buffet table. It is remarkable from today's standpoint that such a lavish arrangement came from a public beach, but it did, and it operated exactly as Robert Moses wanted. People would enter through the side lobbies and see this. On the right, the bathhouse's five large bay windows offered a breathtaking view of the ocean. During World War II, the Marine Dining Room was converted into a soldiers' lounge, a way the LISPC showed appreciation to service members.

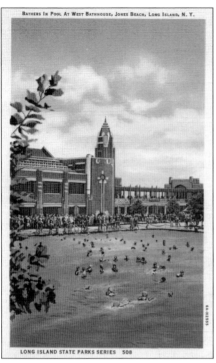

The idealized view of the West Bathhouse swimming pool on this linen postcard makes it look more like a watering hole set in nature's bosom. Beholding this scene, the viewer cannot help but be drawn in. Though done with subtlety, the strategically placed branch fosters the illusion that this is a wondrous yet private place, with the bathhouse vaguely resembling a storybook castle. One gains a sense of perpetually bright sunshine and that the weather is always right for a swim.

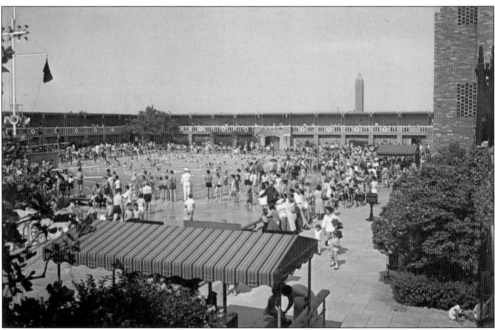

Featured in this Kodachrome is a realistic view of the West Bathhouse's courtyard, showing the deck that encircled both bathhouse pools, one for adults and a smaller one for children. The wall's perimeter sealed off the area on three sides, while the bathhouse's northern elevation closed off the fourth. The center of the bathhouse ran to nearly 64,000 square feet. Faux life preservers were positioned along the cast stone railings, but real ones were positioned in each bay on the courtyard's railing.

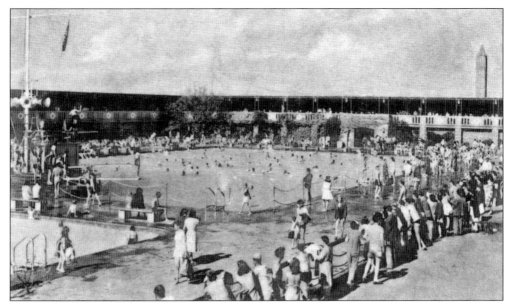

An older view shows pool activity taking place in the West Bathhouse. The children's pool is visible at the lower left, with a child having just emerged from it. People seem to enjoy themselves just being spectators. Note the two individuals on the diving boards, with the young man on the higher board signaling his imminent dive. Note, too, the loudspeakers on the flagpole. During World War II, at 6:00 p.m., everyone would be instructed to stop what he or she was doing to observe the colors being retired to a recording of "The Star-Spangled Banner" piped in from the Central Mall.

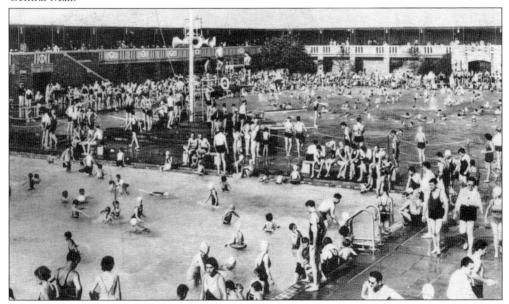

Another older view shows abundant activity, though this postcard, stamped in 1938, focuses on the children's pool in the foreground. A swimming class appears to be in session. Following Robert Moses's personal love of swimming, the West Bathhouse offered free swimming lessons. Over the years, more than a thousand youngsters learned how to swim this way. On this postcard, Dot writes to her friend simply, "Wish you could be here."

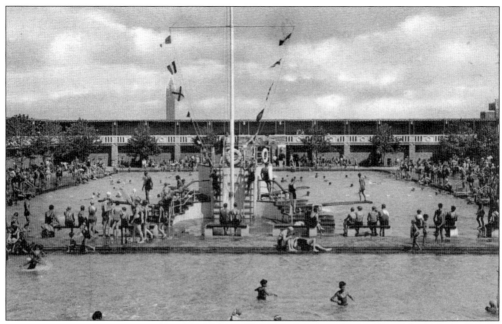

Printed in 1932, this postcard depicts a head-on view of bathhouse's pools as seen from the eastern end of the courtyard. Judging from the bright sky, it is either late morning or early afternoon. Regardless, a fun day lies ahead.

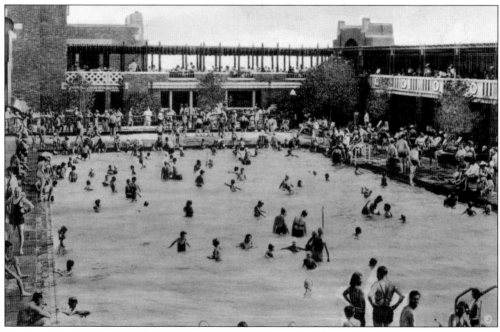

One amenity the West Bathhouse offered was a pool reserved for youngsters that could be heated (something the LISPC, which printed this postcard, points out on its back). In this c. 1930s watercolor rendering, one can see how well received it was.

In a unique perspective of the West Bathhouse's pools, the one meant for children is dominant in the foreground. The canopy under which this photograph was taken serves to frame it as well. It is possible that the planting seen here inspired the idealized view of the West Bathhouse on page 74. The flagpole stands tall once again, though here to provide balance to the composition.

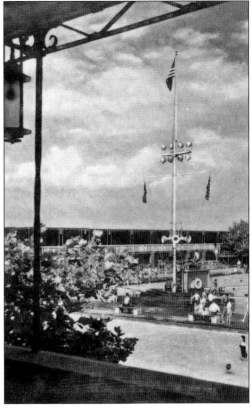

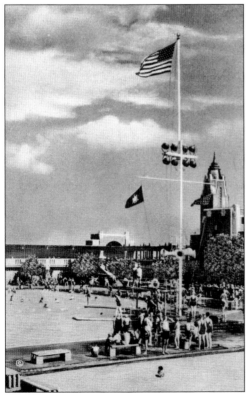

The flagpole accounts for this c. 1940s postcard's verticality. With Old Glory waving in the wind, a patriotic message is conveyed. Subordinate to it on both sides are the state flag and the Union Jack. Note how this photograph was carefully overexposed, shown in the lack of detail in the pool in front (the youngster's head and shoulders seem to float on the surface of the water). Maybe this was to enhance the sky or to catch the stars in the flags.

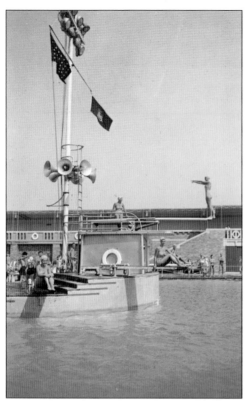

In this Kodachrome, a diving team or water ballet troupe is gearing up to entertain the visitors to the West Bathhouse. As one of these team members is ready to dive into the water, the rest are at ease on the diving boards. Maybe their show is set to begin or they are just in rehearsal.

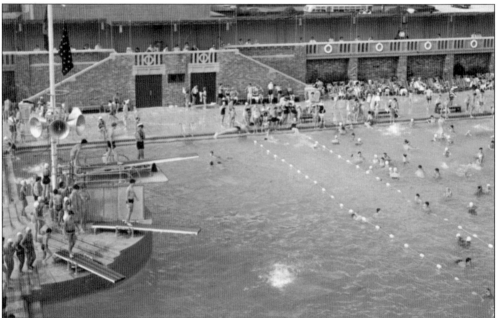

The image on this postcard seems to be saying that if people were not having fun at Jones Beach, it was because they were not trying hard enough. Here, a youngster just bravely dove off the top board—notice his extended body—while someone just plunked into the water. Such fun, caught on Kodachrome cards, solidified Jones Beach's reputation as a wholesome, family-centered venue.

Annual leaflets such as this one, printed for patrons during the 1940 summer season, list the different prices associated with Jones Beach—from the various rentals to the shows taking place to dining options and even the toll amount to go onto the Jones Beach Causeway (note the discount one would have if one chose to buy parking books). Renting an individual dressing room for the season at the East Bathhouse, for example, went for $7; at the West Bathhouse, $15 (in 2017, these would be $120.72 and $258.68 respectively).

JONES BEACH STATE PARK
WANTAGH, LONG ISLAND, N. Y.
SCHEDULE OF PRICES—SEASON OF 1940

BATHING
East Bathhouse

Locker, Child	$0.15
Locker, Adult	.35
Individual Dressing Room	.75
Additional Occupant in Dressing Room	.25
Season Week Day Locker Ticket, Child $1.50, Adult..	4.00
Season Dressing Room, Individual	7.00
†Suit Rental 50c—Deposit	.50
†Towel Rental 10c—Deposit	.15
†Valuable Checking	.10

†—Same price at both Bathhouses.

West Bathhouse
(Prices include use of Heated Salt Water Pools)

Locker, Child	$0.40
Locker, Adult	.60
Individual Dressing Room	1.00
Additional Occupant in Dressing Room	.50
Pool Admission (Non-users of West Bathhouse)	.25
Season Week Day Locker Ticket, Child $3.00, Adult..	8.00
Season Dressing Room, Individual	15.00
Swimming Instruction—Per Lesson	1.00
Book of Six Tickets	5.00

CAUSEWAY TOLL

There are two causeways from the mainland, and the Loop Causeway from Long Beach. The round trip toll is 25c per car.

PARKING

There are six parking fields with a capacity of 15,500 cars at Jones Beach State Park. The parking charge is 25c per car per day.

REDUCED RATE COMBINATION TOLL AND PARKING BOOKS

Ten Trip	$3.00
Monthly	3.00
Season—(May 25 to Sept. 30, incl.)	8.00
Yearly—(to Dec. 31, 1940)	10.00

All tickets are good on Sundays and Holidays as well as week days.

OTHER FACILITIES

Beach Chair or Beach Umbrella Rental	$.50
Deposit on each article rented	.50
Wheel Chairs, per person, per half hour	.25
Rowboats, per hour, 25c—per day	1.00
Bait on Sale at Fishing Station	
Pitch-Putt Golf Course	.50
Deck Games, per person, per half hour	.10
Pedal Boating, per person, per half hour	.25

Beach Supplies are available at the six Beach Shops at moderate prices

JONES BEACH STADIUM

Water Shows and Fireworks Displays—Prices 25c and 40c
Children under 14 Years—15c

FOODS

Refreshments at popular prices may be obtained at the self-service food stands located throughout the Park.
Table d'hote and a la carte meals at reasonable prices are served in the Marine Dining Room at the West Bathhouse and in the Boardwalk Cafe at the Central Mall.

	Marine Dining Room	Boardwalk Cafe
Luncheon, Week Days	$.75	
Afternoon Tea		$.50
Dinner	1.25	1.50 (Incl. dancing)
Shore Dinner	2.00	2.25 (Incl. dancing)

6-15-40-50,000 (16G-9735) Printed in U.S.A.

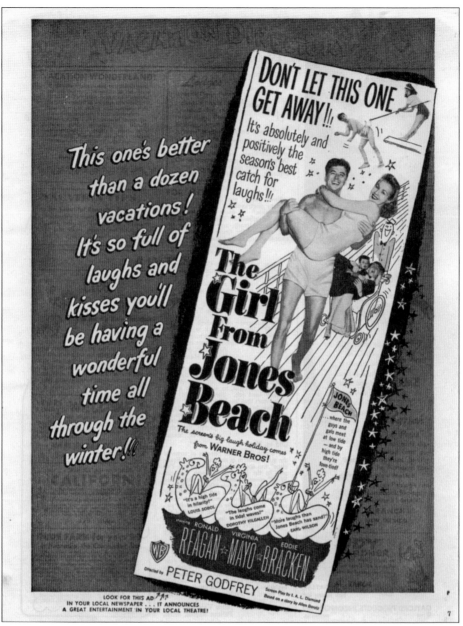

It is well known that before Ronald Reagan's success in politics, he was a journeyman actor. Among the roles he played was artist Bob Randolph in the light comedy *The Girl from Jones Beach*, released by Warner Bros. in 1949. Costarring is Eddie Bracken as Chuck Donovan, a floundering talent agent quixotically seeking the identity of an ideal model ("the Randolph Girl"), who was actually a fictional composite of 12 separate models done by Randolph. Virginia Mayo plays Ruth Wilson, a beauteous yet serious-minded language teacher Donovan takes notice of one fateful day at Jones Beach who by happenstance resembles the elusive model. To win her confidence, Donovan and Randolph hatch a plan for Randolph to act like a Czech immigrant looking to have her give him lessons. Reagan's Czech persona, Robert Vavenik, takes Wilson on a date, where he sets out to embrace her, gamely uttering, "When in Rome, do like they do at Jones Beach."

Four

THE BEACH AND THE BAY

An active swimmer throughout his life (who, at advanced age, swam so robustly that his aides assigned to trail him in the ocean found it exhausting to keep up), Robert Moses was certain that access to the natural bodies of water along Long Island would only enhance the public's welfare. This overriding belief of his inspired not only Jones Beach's creation but also that of other public beaches within Long Island's park system. For their part, it did not take long before Jones Beach enthusiasts regarded the Atlantic or Zachs Bay as their own restorative, an Eden thinly disguised. Under a cloudless day in July, who could blame them?

Transforming Jones Island into a world-famous beach was an impressive feat of engineering. When Moses first trod upon it, it was a sandbar scarcely above sea level, a problem since storm tides would swell from six to eight feet. Under his supervision, 40 million cubic yards of sand—an amount equal to two Hoover Dams—was dredged to raise the beach a total of 14 feet. (The immense hollow from the digging later became the State Boat Channel.) According to the July 5, 1941, *Saturday Evening Post*, what the workers endured on the job included the following:

> [Chief engineer] Arthur Howland and [crewman] Sidney Shapiro . . . never go for a swim at Jones Beach today without thinking about that dredging job. . . . For ten days the crew was marooned . . . when huge ice packs filled the bay. . . . "We had plenty of pancake flour and very little else toward the end of the ten days; I still can't eat pancakes even now, more than ten years later," Shapiro recalls.

Jones Beach's attendance peaked after World War II, reflecting the nationwide growth of the middle class as the engine of economic prosperity. Before the rise of backyard pools and air-conditioning, beaches were attended to cool families off during the summer. "For the time being," observed Lena Lenek and Gideon Bosker, authors of *The Beach: The History of Paradise on Earth*, "Americans were convinced that they had never had it so good, and nowhere was the cult of the joyous nuclear American family expressed with more verve than on the nation's beaches."

It is little wonder why Jones Beach's popularity continued. New Yorkers realized how much of a gem it was—a gem they were proud to call their own.

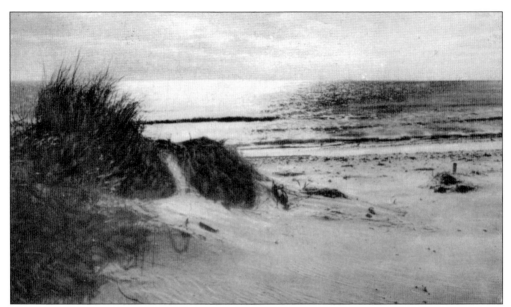

Here lie the basic ingredients for Jones Beach's triumph: sand and surf. Much like the first image presented in this book, this tranquil scene of the sun kissing the ocean and the timeless dune in front give the postcard viewer the reason for Jones Beach's creation. Rather slyly, this postcard will have one believe that Jones Beach was a private getaway where the day could be spent in an idyllic secluded spot such as this one. As Jones Beach was a public beach, nothing was further from the truth.

An early scene includes a pair of beachgoers heading toward the shelter along the boardwalk. The location appears to be on the beach's eastern end, the view facing west, with the East Bathhouse and water tower looming in the distance. With the day early and bright, some sunbathers chose not to be as near to the shoreline as others were.

The beauty of enjoying the beach is purely an individual experience. Those who claim to love the beach are either those who spend all day basking in the quiet warmth of the sun (as seen in the prior image) or those willing to spend hours on the shore. Both have equal claim to the title of beachcomber or beach bum.

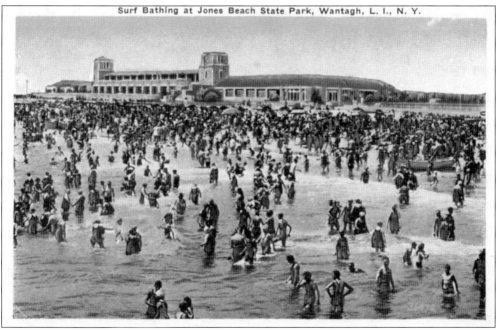

This is a curious c. 1940s postcard rendering. Jones Beach was and still is known for its breakers along its shoreline. To those who respect their intensity, these breakers are a beloved part of the beach experience. But because the water shown here appears unusually placid, even shallow in some spots, it makes for an unusually dense beach crowd, something that suited the purposes of this postcard renderer (Brooklyn's Miller Art Company) just fine. It is, in the end, a rather shrewd take on the masses enjoying a day at Jones Beach.

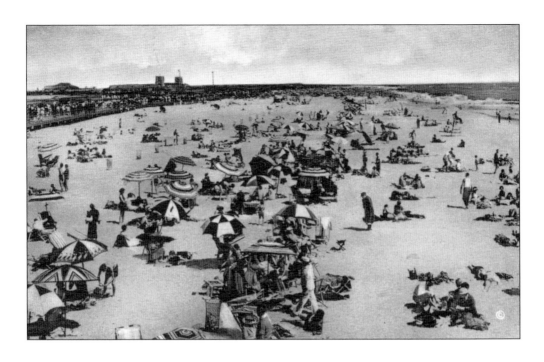

Two early beach scenes are taken from two opposite directions, each with its own landmark as a point of reference. The view above is facing east, with the East Bathhouse in the distance. Below, the busier (and visually brighter) scene is facing west, with the water tower on the horizon. As with many prior images, such depictions intended to show Jones Beach's popularity through the degree of its attendance. Of the two, the view below conveys this better, though the one above does offer a glimpse of a teeming boardwalk.

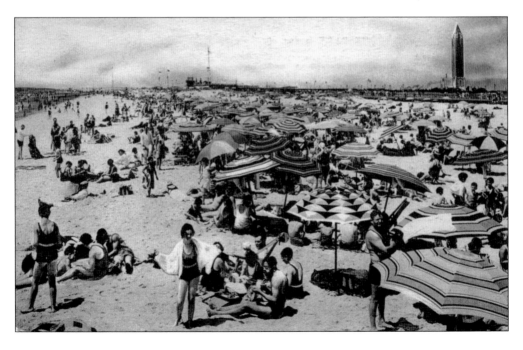

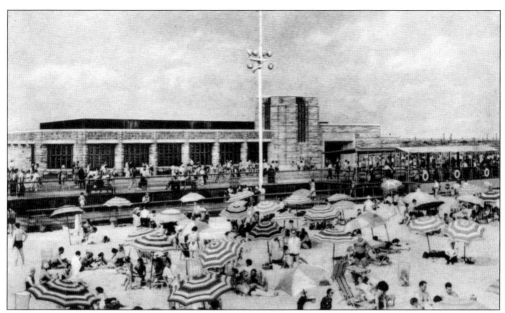

Architecturally speaking, the Boardwalk Café was designed to be a part of an Art Deco ensemble, something its modernistic replacement (see page 63) was not. For a summer beach scene, everything is remarkably well-mannered and spotless; notice the trash cans within arm's reach. And while many patrons saw fit to set up their umbrellas near the boardwalk, others were just as satisfied to take in the sea air while sitting under the boardwalk shelter to the right.

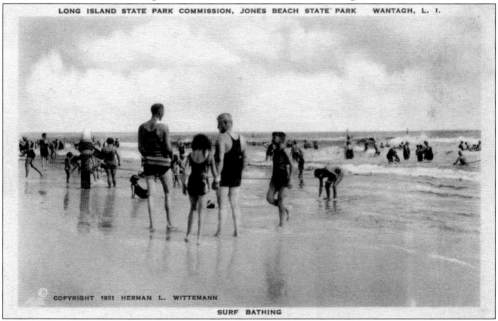

This early image of Jones Beach shows activity on the shoreline vaguely similar to that at High Hill Beach (see page 24). A young woman is situated between two men clad in full-body swimsuits. She is holding hands with the man on the right. While High Hill Beach saw the barriers between the sexes starting to break, Jones Beach took it as step further to establish social norms considered natural today.

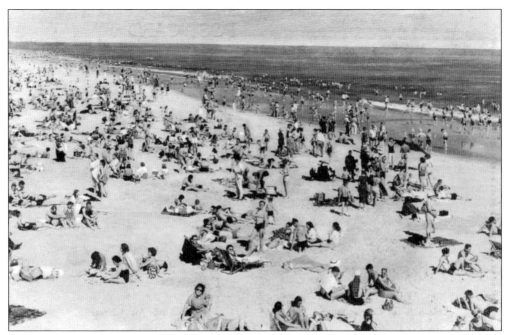

Another beach view, with a higher perspective than those previous, directs one's gaze to the ocean's expanse. It is an active beach scene. However, the woman down in front with sunglasses looking up toward the camera catches the reader's attention. Perhaps without the photographer noticing, she observes how high he is perched for this picture. While wide-angled panoramas make for dazzling postcards, details such as this are no less interesting and are even amusing.

Presented as though it were a warning, this ominous scene reveals that the beachfront does have a darker side. Labeled *Storm at Sea*, the postcard reveals how turbulent the surf can potentially be and that, when this occurs, it is not to be trifled with. Note the pair of people to the lower right making their way across, offering the image a sense of scale.

To describe the goings-on in this postcard, its caption blandly reads: "Fun." But this word does not seem to fully capture how the children are having the time of their lives in a world of their own making along the shore. Among them is a broad-shouldered lifeguard keeping an eye on those deeper into the ocean. Such vigilance gave the Jones Beach lifeguard corps a well-deserved good reputation.

Some beach scenes are timeless. In this 1953 image, the boys in the foreground are absorbed in making their own sandcastle. The couple behind them are enjoying a moment of togetherness. (Perhaps they are seeing their baby take to the beach for first time.) And there are always those who stand by the shoreline breathing in the air and enjoying the surf while taking in the panorama before them. This photograph captures the essence of fun at the beach: it is all about just doing one's own thing.

This handsome portrait shows the members of the Jones Beach lifeguard patrol around 1932, with its captain, lieutenant, and boatswain on top. Capt. William Johns, seated in the center, led the operation. Jones Beach's lifeguard team won the Long Island Lifeguard Tournament in 1931 and 1932. Also in 1932, the team won the Atlantic Coast Championship. According to John Hanc, the crew did so again in 1934. Lifeguarding at Jones Beach was serious business. As Reggie Jones, who began his stint in 1944 and retired only recently, recalled: "[It was] the closest thing to military camp you could imagine. . . . We lined up like soldiers at the Central Mall, at stiff attention, and we had to stand inspection. I was a young kid, facing the Atlantic, scared to death!" The corps proved quite heroic in the 1940s, with a total of 1,709 rescues and no drownings in 1947 alone. Jones's son is currently the no. 2 man at Jones Beach.

Though taken years apart, these picture postcards show virtually identical ocean views. In each, the lifeboat waits, always on the ready.

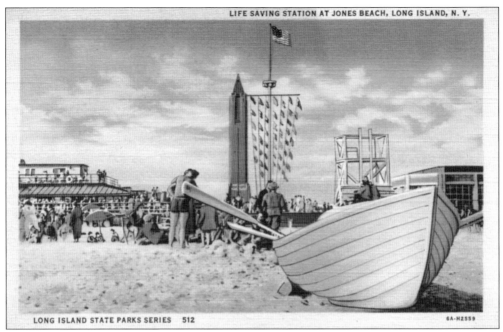

LONG ISLAND STATE PARKS SERIES 512 6A-H2559

In an atypical rendering, this postcard prominently features the lifeboat at the forefront. Given its role in lifesaving situations, the boat's importance remains; there are always people who never learn to respect the ocean as they should. This accounts for why these lifeboats, with their sturdy oars, have been considered mandatory equipment on beaches for more than a century.

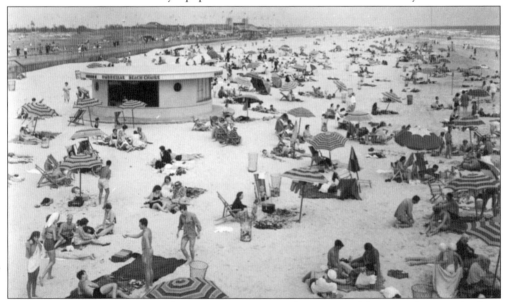

Another scene in an early Kodachrome was taken west of the East Bathhouse with a view looking towards the Central Mall. Plainly visible is the kiosk where beach chairs and umbrellas could be rented for the day. Umbrellas were standard Jones Beach issue, striped green and orange. While the presence of so many identical umbrellas could hamper one from finding one's chosen spot on the sand, they were convenient nonetheless. A canvas shop on premises helped to ensure that they were in good working order.

Many have long sworn by the positive effects of being in the sun. That it is an important source of vitamin D validates such a claim, but firm believers, like the author's wife, are quick to speak in less clinical terms. With that in mind, a band of sun worshippers takes in some rays. Sunburn was always a risk, and caution should also extend to the potential danger of skin cancer. Taking proper precautions is now common knowledge, but many still consider an ideal beach day to be one like this.

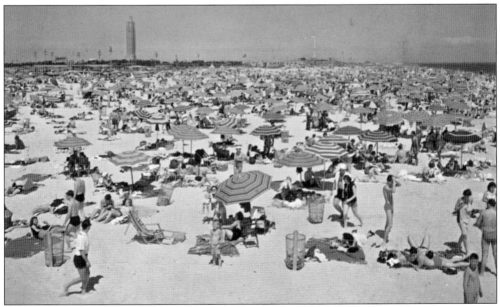

In this late 1950s or early 1960s Kodachrome by Tomlin Art Company, the number of beachgoers (viewed east from the West Bathhouse) is, in a word, astonishing. Public beaches have been characterized as a social equalizer, and Jones Beach lends itself to that description. With everyone having a place on the sand, no one is above anyone else: real-life democracy at its finest.

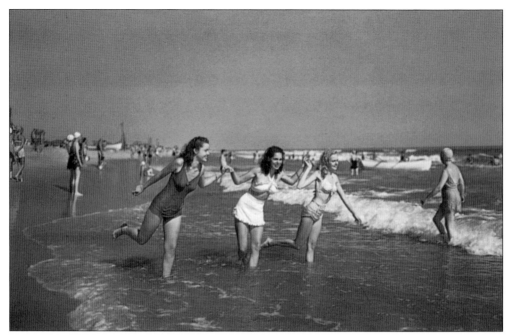

Three young women are shown skipping hand in hand along the shore. Only they can tell what went into this pose, but it makes for an appealing postcard. Unlike the woman on the right, they seem unaware that a lifeboat is heading out toward the ocean, maybe for a rescue.

As opposed to the previous image, the three women featured in this postcard are enjoying each other's company by the sand dunes with fencing meant to protect the beach from erosion. Seeking to avoid the beach's openness, these young women found privacy in an alcove.

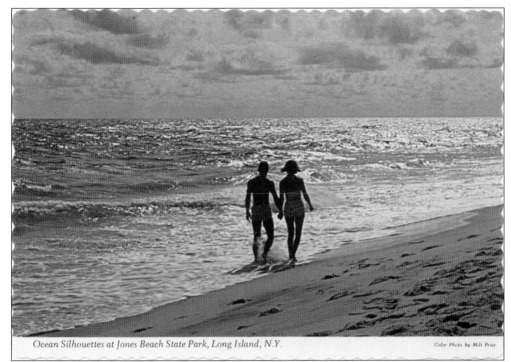

Ocean Silhouettes at Jones Beach State Park, Long Island, N.Y. Color Photo by Milt Price

Seen here is a couple along the shoreline supposedly at Jones Beach; an identical postcard image exists that claims to depict Fire Island. While not the first to engage in this practice, Tomlin Art Company made a choice to label pictures of indeterminate location under different headings that borders on being deceptive. To postcard receivers ignorant of this, the caption is taken at face value. Yet to others who happen to know differently, the postcard's disingenuousness makes it something of a letdown.

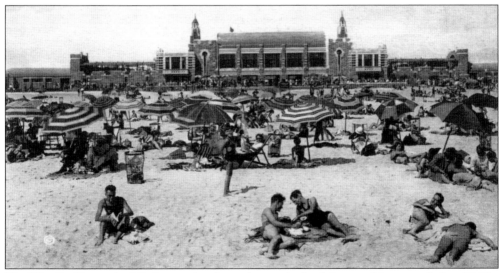

The West Bathhouse in full glory makes for an impressive backdrop to this postcard view. Unlike its reserved counterpart to the east, the larger and showier West Bathhouse not only takes up the length of this postcard but also gives a sense of the breadth of this beach scene. The photographer did a fine job catching this wide-angled view in such detail.

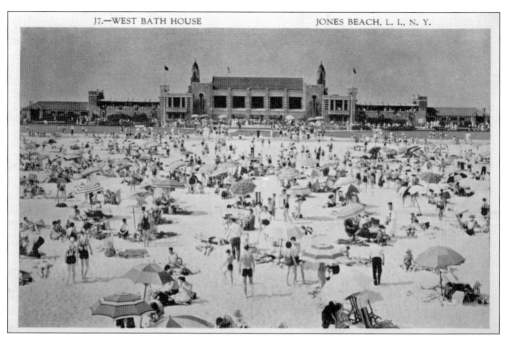

A view of the West Bathhouse from the same vantage point as before, this one was taken from a higher angle. Both this and the prior image catch the distance between the bathhouse and the beach itself. From near the ocean, it might have taken more than five minutes to reach the bathhouse. Yet as one approached it, the visual drama of it looming ahead was indeed impressive.

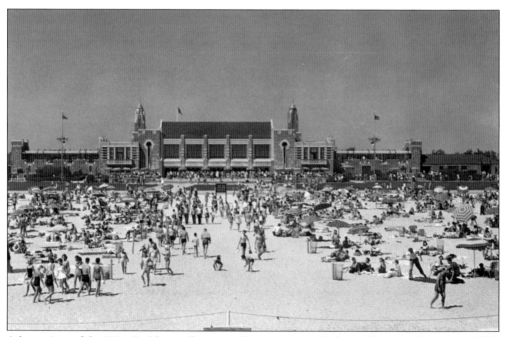

A later view of the West Bathhouse from a similar perspective is featured on a mid- or late-1950s Kodachrome. The cloudless sky is an awesome deep blue, making the West Bathhouse stand out with striking clarity.

94

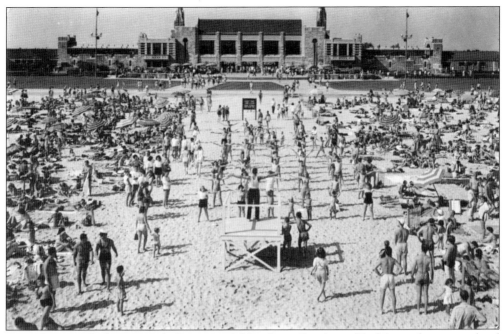

By enthusiastically boasting wholesome activities, Jones Beach could claim to be a step ahead of other public beaches in promoting the public's welfare. Among such activities were spirited rounds of calisthenics, seen here. Note the outstretched arms of the instructor guiding a group of willing participants.

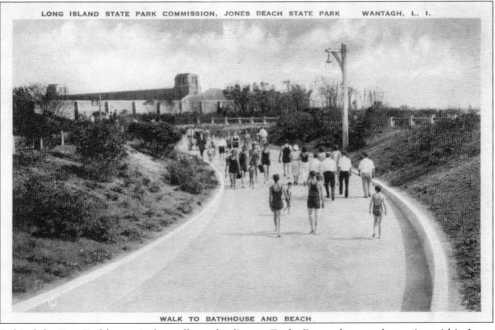

LONG ISLAND STATE PARK COMMISSION, JONES BEACH STATE PARK WANTAGH, L. I.

WALK TO BATHHOUSE AND BEACH

Behind the East Bathhouse is the walkway leading to Zachs Bay, a pleasant alternative within Jones Beach. Like the rest of the park, the manicured walkway made for a leisurely stroll for patrons going to and from the bay.

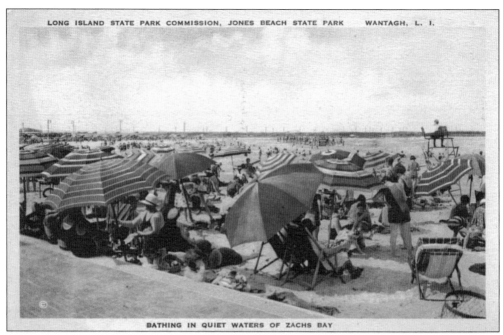

BATHING IN QUIET WATERS OF ZACHS BAY

As judged by the number of beach umbrellas present, this crowded scene offers a sense of how popular Zachs Bay was. While everyone came to enjoy it, it was favored by parents with young children for its still waters. Notwithstanding, to the right is an ever-vigilant lifeguard, just in case.

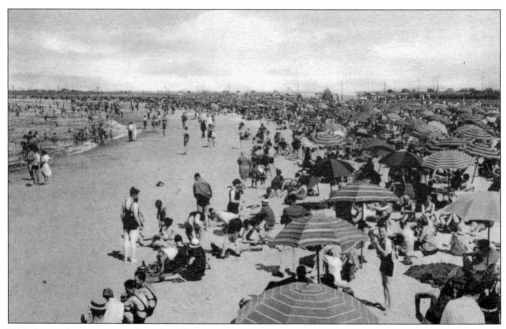

This is another expansive but densely packed summertime scene at Zachs Bay. The crush of people in this image appears to make the bay into something of a friendly rival to the ocean. While many are oblivious to a camera pointed at them, ostensibly to take this postcard, one patron happened to notice the photographer present.

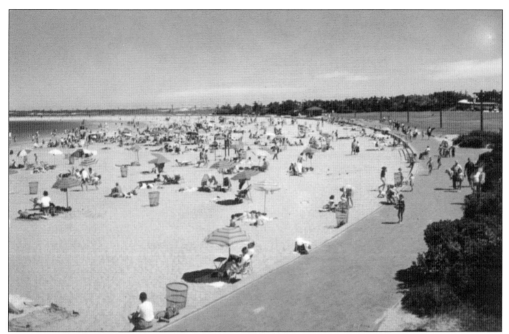

A later, less congested view of Zachs Bay is from a Kodachrome postcard. The bay's crescent shape is apparent. Unfortunately, this bay has been subjected to years of erosion, made worse with Hurricane Sandy's impact. Oddly, Elsa writes on the back of this card that seven people were rescued on this day, "so you can imagine what the waves are like."

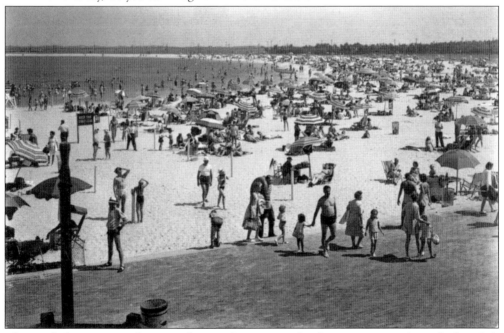

This Kodachrome view shows Zachs Bay from practically the same perspective as before. It is midafternoon, and the beach is still heavily populated. That the bay was family-friendly seems to be borne out with the minor activity seen in front. Maybe these parents decided it was time to pack up and go home. If so, one can sympathize with their children wanting more playtime.

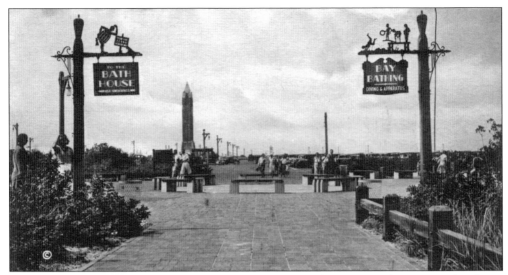

This short walkway led (and still leads) into the parking lot adjacent to Zachs Bay. It makes for an unexceptional postcard scene except for the two silhouetted signs typical of many throughout the park. Each amusing in its own way, these signs put patrons at ease as they directed them to a given area (as seen in this photograph) or charged them to observe an important rule. Such signs were undeniably a part of Jones Beach's charm.

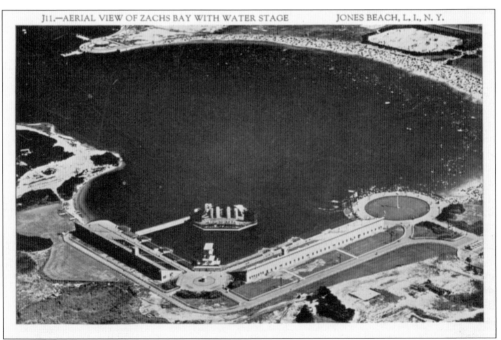

An extraordinary aerial view shows the first Marine Stadium at Zachs Bay. Built in 1930 as a work relief project, it was a wooden open-air structure used to host early theatrical productions, in addition to water shows with top Olympic swimmers and even circus productions. It was demolished to make way for the much larger Marine Theater in 1952 that, according to John Hanc, was "more befitting of the now world famous beach." Operettas were also performed, as were firework displays (see pages 111–115).

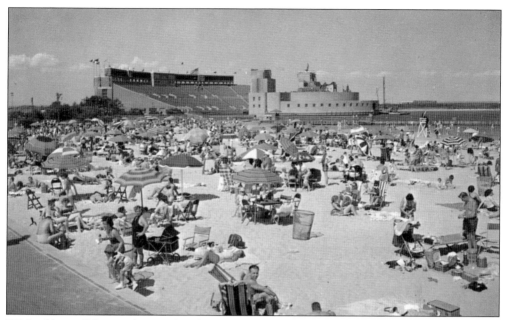

While this candid view depicts the afternoon crowd enjoying the day Zachs Bay, its focus is the new and imposing Marine Theater located in back. Once again, the curiosity of an onlooker down in front is caught by the photographer.

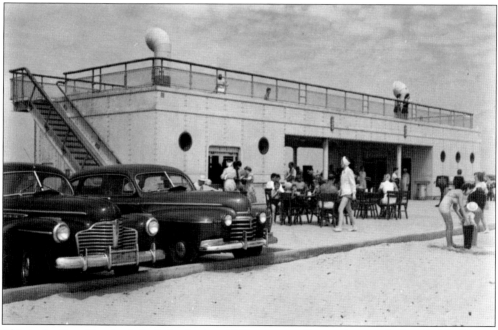

This is the East Overlook, built in the late 1930s as a comfort station on the beach side (that is, south of Ocean Parkway) east of Field 6 across from Zachs Bay. Jones Beach's nautical theme is evident in the observation deck resembling a smaller version of the boardwalk proper; note the ship funnels, mahogany railing, and porthole windows flanking the concession window behind the bulbous-nosed parked cars. The East Overlook was demolished in the late 1970s.

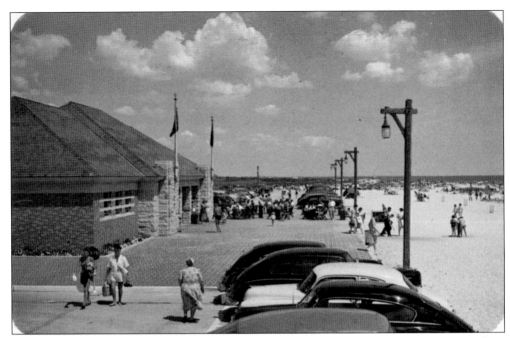

Marking the end of the boardwalk on the eastern part of the beach was the Ocean Front Pavilion. What's interesting is how the cars parked alongside the edge lend to a pleasantly intimate setting. Imagine the satisfaction of those who found such parking spaces; not only was it convenient, but there was a sense that—unlike the central portion of the beach, or even Zachs Bay—this was a private, even exclusive, domain.

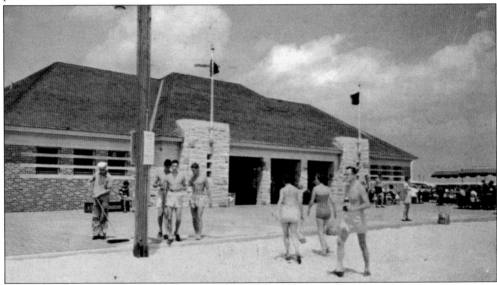

Unlike the East Overlook, the Ocean Front Pavilion fell mainly in line with the rest of the architecture of Jones Beach. One distinction is that a lighter yellow sandstone was used in key parts of the building instead of the original, much-preferred Ohio sandstone. Built in the 1950s also as a comfort station, it offered a snack bar, gift shop, and bathroom facilities. It was expanded in the 1980s, but it is said that the work quality of the added wings fell far short of what already the existed within the structure.

Five

A SLICE OF THE GOOD LIFE

"If father wants to play golf, and mother and Junior want to go swimming," Jones Beach Park superintendent Stanley Polek was quoted as saying, "the happy solution is Jones Beach." While a breezy appraisal, it only begins to allude to how Jones Beach offered people a slice of the good life. From archery, to roller-skating, to the daily turtle races at the Indian Village, the park's many recreational activities facilitated this. This was a time when public leisure was considered an official priority. But there was a happy corollary to all this: having people come together in an atmosphere of honest fun did no less than advance the spirit of democracy.

Another mode of the good life offered was the musical extravaganzas at the Marine Theater, an imposing 8,000-seat playhouse with a stage 104 feet wide, a revolving stage 76 feet wide, an underwater tunnel, and a 100-foot lagoon. It has gone through several upgrades since. As Norwell Health became its lead sponsor in early 2017, it is now called the Norwell Health at Jones Beach Theater.

Forever associated with these extravaganzas is the renowned bandleader Guy Lombardo. After Moses rejected impresario Billy Rose and producer Mike Todd failed him, he arranged for Lombardo to produce *Arabian Nights*, ushering in a golden age of entertainment at Jones Beach. Despite cost overruns, Moses stood firmly by him:

> Those who have shared with him the vicissitudes of outdoor theatrical production, the chances of artistic achievement and the gambles of success, admire his spirit, his unflagging enthusiasm and his loyalty to his family, his band of friends. It is heartening to know that with the great majority, which is supposed to be fickle and undependable, Guy Lombardo has never lost his popularity.

Lombardo relished his experience at Jones Beach. Residing in the village of Freeport, where he owned the East Point House (a seafood restaurant), Lombardo, a former speedboat champion, commuted to work on his *Tempo IV*.

Once the Lombardo era faded into memory, the Marine Theater became a go-to place for rock concerts, a change antithetical to Moses's original designs. But leave it to Bob Dylan, who never met Moses, to counter lyrically, if also ironically: "Come gather 'round people / Wherever you roam / And admit that the waters / Around you have grown / And accept it that soon / You'll be drenched to the bone / If your time to you / Is worth savin' / Then you better start swimmin' / Or you'll sink like a stone / For the times they are a-changin'."

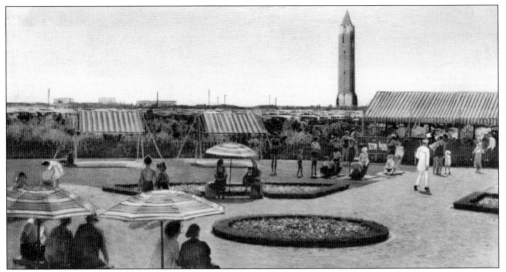

This early Albertype postcard illustrates the Zachs Bay Kindergarten, an all but forgotten and yet thoughtful amenity that was, as its name suggests, a quiet place for mothers to spend some quality time with their children. Notice some youngsters on rocking horses. In the back is a conveniently situated parking field.

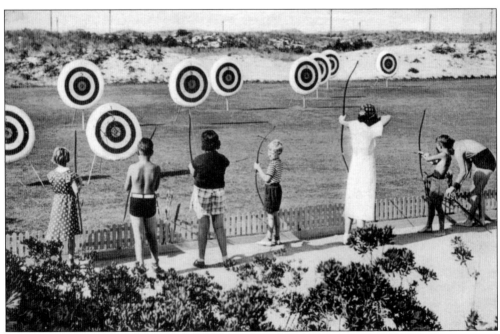

Though most parents today would think twice before allowing their kids to handle bows and arrows, archery was one recreational activity offered them during Jones Beach's early years. Quite different from the brash amusements on Coney Island, archery and other recreational pursuits were seen a way to develop strength (archery fostered greater concentration) and personal character. Note in this postcard the targets set up in varying distances to accommodate children of all skill levels. The older girl in the white outfit looks more experienced—and determined.

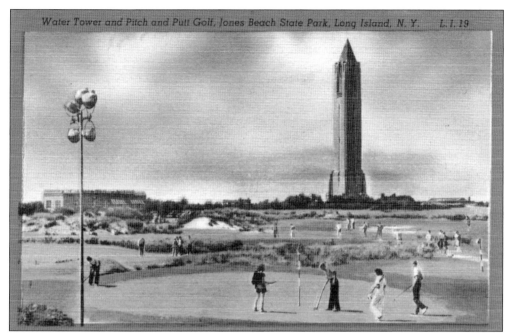

Located in the verdant area east of the Central Mall was the pitch putt (or short game) golf course. A traditionally styled 18-hole golf course with tees, sand traps, putting greens, and hazards, its greens were meticulously tended to. The course abutted dunes and sand, and Jones Beach's signature parterre landscaping was present. In 2013, the course was closed due to the effect of Hurricane Sandy.

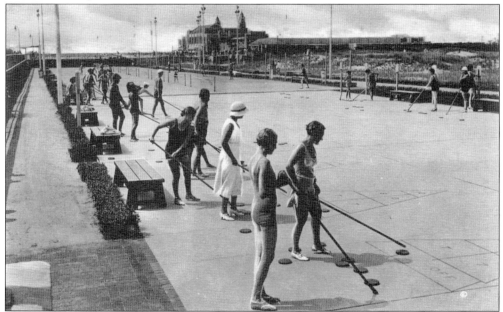

In addition to pitch putt golf, shuffleboard was a popular diversion. This shuffleboard court is located at the west games area facing west, with the West Bathhouse seen in the distance. This early postcard is interesting insofar as it features primarily women taking to the game. Given that shuffleboard is an activity found on ocean liners, it fit in with Jones Beach's overall nautical theme.

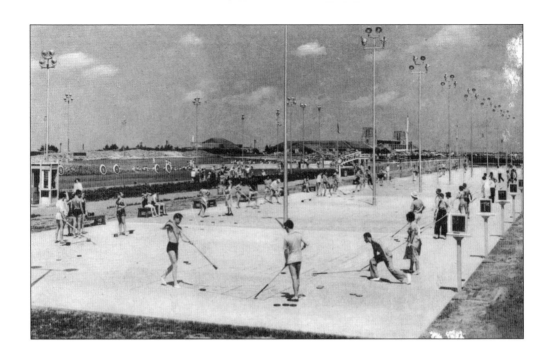

These two shuffleboard views are from opposing games areas. Above is the east games area with much shuffleboard activity (see also the archery field and the East Bathhouse in the background). Today, this area is comprised of basketball courts. Below is a view facing east across the west games area, as the water tower is featured; in the distance is the Indian Village.

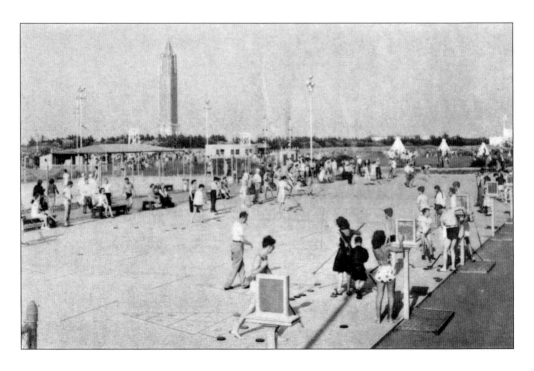

This luggage decal (a period piece) refers to Jones Beach's outdoor roller-skating rink. It cleverly evokes a fun day of roller-skating with—what else?—Jones Beach's lovable mascot straddling an anchor.

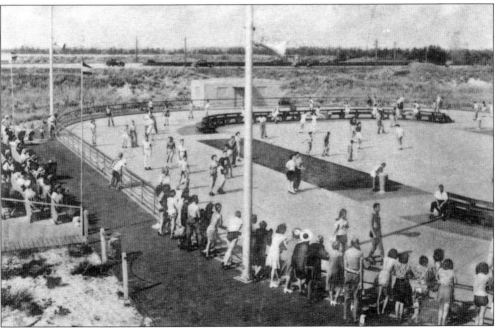

This c. 1940s postcard shows not only roller-skating in full force but also how much of a spectator sport it was, with people watching alongside the rink and in the bleachers to the left. At the center of the image, behind the pole in front, is where skates were rented. What is shown is not the earliest roller rink, as the first was positioned on a square-shaped lot. According to the *Historic Structures and Landscaping Report*, there was also an indoor arena present before this outdoor one. Today, volleyball fields stand on this site.

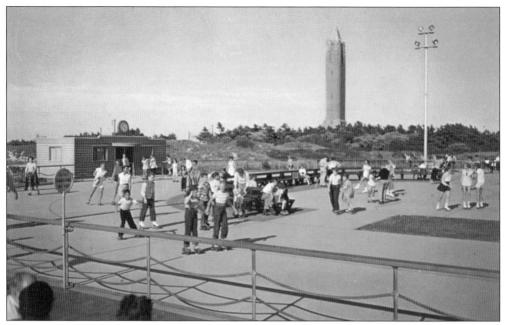

This Kodachrome presents a modern view of the roller rink with the water tower in the distance. Unlike in the prior image, the round sign to the left directs people not to stand near the rink but rather to take a seat on the bleachers while spectating. What precipitated this one can only guess, but it does take something away from the intimate setting that was there before.

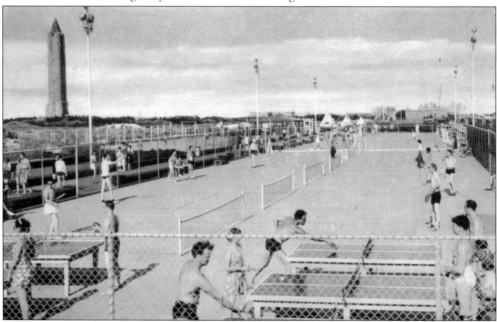

This older image of the west games area shows people actively engaged in table tennis and, behind them, paddle tennis. Like pitch putt golf, which was a condensed version of more traditional golf, space constraints dictated these versions of tennis. However, from the looks of this postcard, those who participated seemed not to mind. Notice the man in front with his arm extended, fully into his game.

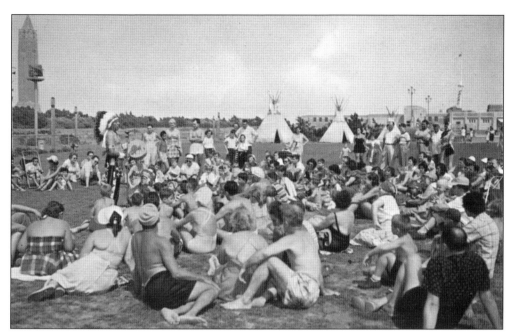

Another charming feature Jones Beach was known for was its Indian Village. In its early years, the star of the show was Rosebud Yellow Robe. To the author's knowledge, no known postcard view of Yellow Robe exists. Yet, as this latter-day postcard shows, the Indian Village would continue to attract many. Note the speaker in full headdress captivating his audience, young and older alike.

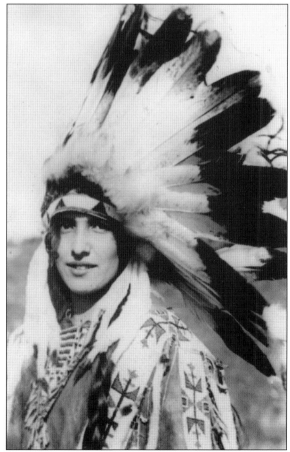

Rosebud Yellow Robe (Lacotawin) (1907–1992) was a Native American folklorist, educator, and author. A much-loved figure in Jones Beach history, Yellow Robe became a celebrity by placing a handmade Lakota war bonnet on Pres. Calvin Coolidge in gratitude for his support of the Indian Citizenship Act of 1924. After he found about her, Robert Moses hired Yellow Robe as director of the Indian Village in 1930. For the next 20 years, she won the hearts of children every summer with her storytelling and her arts and crafts classes exposing them to Sioux culture. This striking picture of Yellow Robe was taken in 1929.

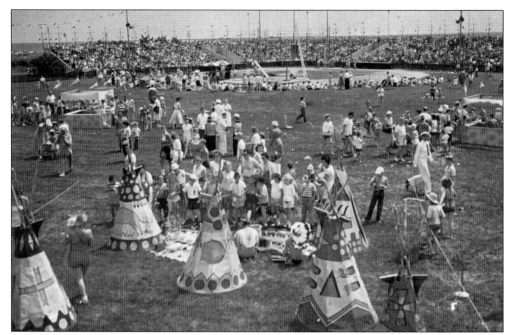

Located behind the softball field, where it looks like a game is set begin, the Indian Village is hosting what appears to be a fair for younger visitors. To have two events like these taking place points to the number of visitors who came to Jones Beach on a given day and the activities offered for their enjoyment.

This unique postcard view shows Circus Day at Jones Beach. While the park's grounds might have called for curtailed forms of sporting activities (like pitch putt golf was to the traditional kind), there was apparently enough space to host an outdoor circus, to the delight of children of all ages.

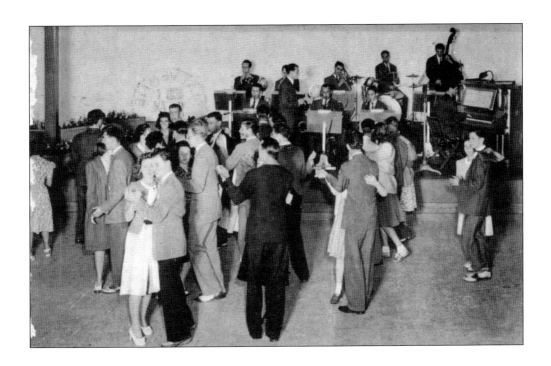

If children were meant to be enthralled with clowns and elephants by day, their parents would find their own richly deserved pleasure in a night of cheek-to-cheek dancing by the band shell or even from within the Boardwalk Café. With the air of decorum in these postcard images—men, for example, were required to wear jackets; sweaters and shirt sleeves were not allowed—the contrast with the incessant noise found at Coney Island could not be more apparent.

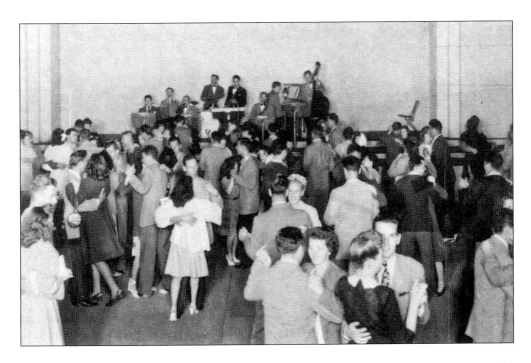

JONES · BEACH · STATE · PARK

PROGRAM OF SPECIAL EVENTS
AUGUST—SEPTEMBER 1941
JONES BEACH STATE PARK

MARINE STADIUM

5 DAYS **GRAND FINALE** **5 DAYS**

8:30 P.M. **SPECIAL WATER SHOW** 8:30 P.M.

Aug. 28, 29, 30 **SONG OF THE ISLANDS** Aug. 31, Sept. 1

with

THE FAMOUS JONES BEACH MAGIC WATER BALLET
BRUCE PARKER and WATER SKIING AND AQUAPLANING TROUPE; PANSY THE
HORSE; BOB HOWARD—Famous Ambassador of Rhythm; BELL'S HAWAIIANS; THE
LIME TRIO—The Golliwog; JERRY BRANNON—Vocalist; BETTY HARRISON, JO CLEAVER,
STANLEY DUDEK, WALTER CLEAVER—Fancy & Acrobatic Diving; DON FERDI AND HIS
RECORDING ORCHESTRA; BILL MARQUETTE & CLOWN TROUPE.

LARGEST FIREWORKS DISPLAYS EVER PRESENTED AT JONES BEACH

RESERVED DOCK CHAIRS 55c 7,000 SEATS 30c — CHILDREN 15c
Reservations may be made at each Bathhouse and at the Administration Office.

BOARDWALK CAFE —Dining and Dancing—CENTRAL MALL

McFARLAND TWINS To Labor Day Night

DON FERDI and **HIS ORCHESTRA** - MONDAY, AUG. 25th

CAFE CLOSES LABOR DAY NIGHT DANCING ALSO AT THE CAFE GARDEN

POOL SHOWS WEST BATHHOUSE **SURFBOARD WATER POLO**
 NO CHARGE FOR SEATS
9:00 P.M. Final Pool Shows—Sunday, Tuesday & Wednesday Nights, Aug. 24, 26, 27
 Final Water Polo Games—Sunday & Tuesday Nights, Aug. 24 & 26 9:00 P.M.
 Water Polo Exhibition & Presentation of Awards—Friday, Aug. 29

SOFTBALL BASEBALL 2 Major Leagues—at Diamond. No Charge for Seats
JONES BEACH LITTLE WORLD'S SERIES Aug. 28 to Sept. 1, Nightly 8:45 P.M., Sun. & Mon. 2:30 P.M.
TWO GAMES NIGHTLY, EXC. SUN. AT 8:45 P.M.—SUN. AFTS.—2:30 P.M.—LAST LEAGUE GAME AUG. 27
EXHIBITION GAMES Sun. AUG. 31 - 1:00 P.M. AND EVERY SUNDAY DURING SEPTEMBER AT 2:30 P.M.

BASKETBALL Roller Skating Rink Near Indian Village. No Charge for Seats
6:30-8:00 P.M. Final League Games—Mon., Thurs., Fri., Sat.,
 Aug. 25, 28, 29 & 30—Championship Play-off—Mon., Sept. 1 6:30-8:00 P.M.

FINAL ROLLER SKATING EXHIBITION Tuesday, Aug. 26 9:45-10:15 P.M.
FINAL SQUARE DANCING Wednesday, Aug. 27 7:30-9:00 P.M.

AMERICAN INDIAN ARTS & CRAFT EXHIBIT Indian Village AUG. 29, 30, 31 & SEPT. 1
OUTDOOR SABRE CONTEST Music Shell SUN., SEPT. 7

FREE OUTDOOR DANCING—Every night to Sept. 6th except Sundays—Sat. night only Sept. 13th—
 9:30 P.M. to Midnight at the Central Mall Music Shell—Paul Muro & Orchestra.
NIGHT BATHING—In the Heated Salt Water Pools at the West Bathhouse every night to Labor Day.
DINING—Marine Dining Room—West Bathhouse—12:00 Noon to 10:00 P.M. to Sept. 7.
PEDAL BOATING—At Zachs Bay every day to Sept. 7.
PITCH PUTT GOLF—All day every day at the course east of the Central Mall.
HOLE-IN-ONE GOLF TOURNAMENT—Every night to Labor Day. Prizes for nearest to cup.
DECK GAMES—ALONG BOARDWALK—Day and Night.
ROLLER SKATING—At the Rink every day and every night.
FISHING STATION—Storehouse—Boats, Bait, Accessories—6:00 A.M. to Sunset daily.
ADULT PLAY AREA—Starting Sept. 6, E. Games Area.
 NO DOGS PERMITTED ON BEACH OR WALKS AT ANY TIME

JONES BEACH STATE PARK

Flyers such as this that announced upcoming events at Jones Beach were distributed monthly. This one, dated August—September 1941, outlines many of the events and activities mentioned in this book. A convenient schematic of Jones Beach is printed on the back.

MARINE CIRCUS

at

Marine Stadium
Jones Beach
L. I.

DIRECT
from
FLORIDA'S
CYPRESS
GARDENS

25¢

PROGRAM
and
SOUVENIR
BOOK

A popular attraction at the Jones Beach Stadium on Zachs Bay was the Marine Circus, held by the Aquamaids and Water-Ski Champions from Cypress Gardens, Florida, billed as "the major center of the world for the development of water skiing, aquaplaning and many other high-speed precision aquatic sports." While Robert Moses felt such water-themed entertainment was necessary to the overall Jones Beach experience, he eventually pushed for larger spectacles.

With performances starting in late July 1936, *Blossom Time*, directed and staged by Edward J. Scanlon, was among the earliest productions held at the Jones Beach Stadium. It was a fictional account of love, loss, and hopeful reunion ("a fascinating interweaving of fact and fiction," as the theater program states) inspired by the real-life experiences of Austrian composer Franz Schubert.

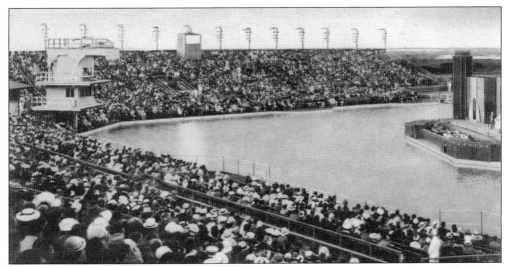

This early postcard's emphasis is not so much on the production taking place but on what looks to be a packed house. While it would have been reasonable to assume that the distance between the stage and the seating posed difficulties for the performers and distant parts of the audience, there is no known record of any issues. Yet the impresario Billy Rose, who made his mark with the Aquacade in the 1939 New York World's Fair, made it clear to Robert Moses that the Marine Stadium's lagoon was a liability. Moses found Rose's personality disagreeable, and so Rose never performed at Jones Beach.

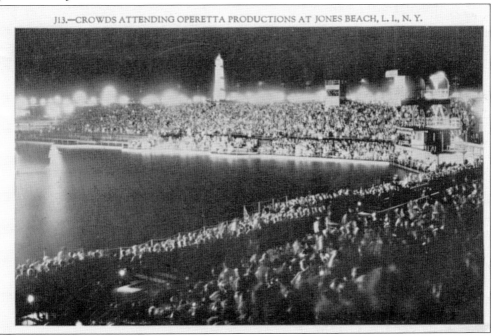

Though a blurred image, this wide-angle photo postcard (like the previous one) shows the full extent of the audience. At the same time, Jones Beach's productions were a way for the park to garner those with refined tastes. Toward this end, the catchphrase "over the water and under the stars" was used to lure those who felt a Broadway show was beyond their immediate reach, physically or financially.

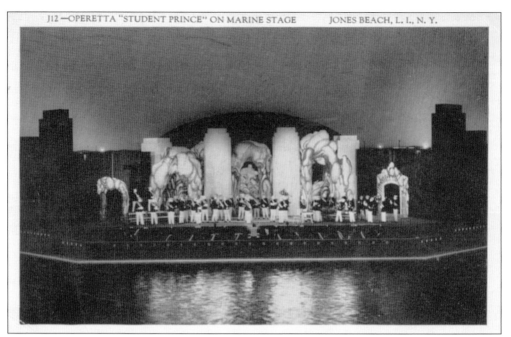

Here is a Jones Beach–based production of *Student Prince*, a four-act operetta based on Wilhelm Meyer-Forster's play *Old Heidelberg*, with music from Sigmund Romberg and lyrics by Dorothy Donnelly. *Student Prince* was Romberg's most successful show, with a run of 608 performances in Manhattan during the 1920s. A lighthearted romantic story, it was Moses's idea of what popular entertainment at Jones Beach should be. One memorable upbeat song was "Drink, Drink, Drink!," later popularized by the famed tenor Mario Lanza.

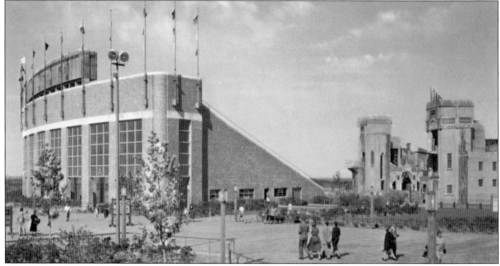

Citing safety concerns, Robert Moses razed the Jones Beach Marine Stadium—a wooden structure built as a work relief project—in 1945. Its replacement, the Jones Beach Marine Theater, was completed in 1952. For nearly 30 years, it was the venue for large-scale musical extravaganzas (where at times Jones Beach lifeguards played bit parts). "Air-conditioned-by-nature" (as John Hanc put it), the Marine Theater was touted as an ideal way to enjoy a musical—though in this Kodachrome, it looks dormant.

114

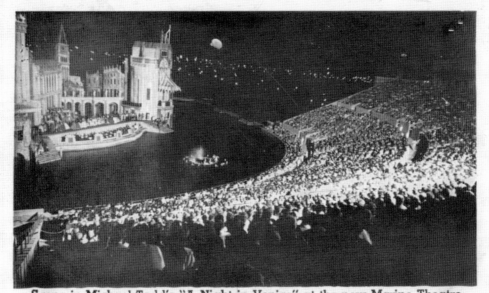

Scene in Michael Todd's "A Night in Venice" at the new Marine Theatre, Jones Beach State Park, Wantagh, Long Island, N. Y.

Eager to bring the best shows to the Marine Theater, Robert Moses recruited Broadway producer Michael Todd to stage Johann Strauss's *A Night in Venice* as its inaugural performance. Todd was Elizabeth Taylor's future husband, making them an instantly recognizable celebrity couple. Yet Todd's *A Night in Venice* was, despite its extravagance, a critical flop (contradicting this postcard). Todd's departure after the 1953 season would usher in the era of Guy Lombardo, a high point in Jones Beach history.

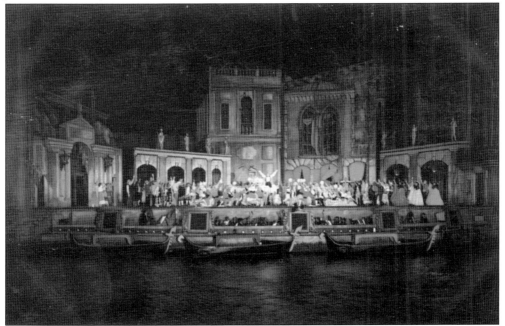

This Kodachrome postcard presents a view of *A Night in Venice* onstage. How convenient it must have been to have the lagoon in which to place the gondolas—a most realistic touch!

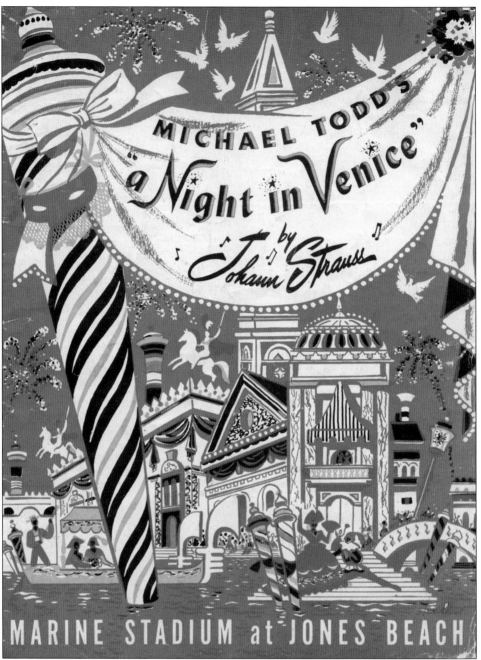

MICHAEL TODD'S "a Night in Venice" by Johann Strauss

MARINE STADIUM at JONES BEACH

Along with a synopsis of the story line and brief bios of cast members and Michael Todd, this program of *A Night in Venice* printed an open letter by Robert Moses that promoted the new Marine Theater. In it, he describes its impressive dimensions and that it is "designed for a wide variety of wholesome outdoor summer entertainment for large numbers of people." He states how befitting *A Night in Venice* was for this new venue: "We believe that the performances ... scheduled by the Michael Todd organization provide entertainment of a type and scale appropriate in this marine setting and in full keeping with the standards established by the Long Island State Park Commission at Jones Beach State Park." The prior postcard was intended to capture that.

Guy Lombardo (1902–1977) was a renowned Canadian-born bandleader and Moses favorite. After Michael Todd left, Moses persuaded Lombardo to do a season of choreographing at the Marine Theater. Lombardo recalled that "[Moses] liked our style, our reputation for presenting good, clean entertainment." His *Arabian Nights* met acclaim, but because of cost overruns, Lombardo considered stepping down. To keep him, Moses allocated state monies to bankroll future productions ("a gigantic adventure in recreational socialism," observed the *New York Herald Tribune*).

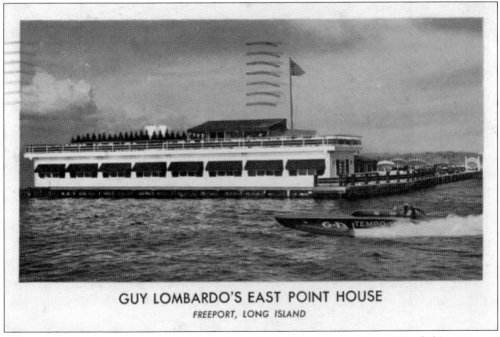

GUY LOMBARDO'S EAST POINT HOUSE
FREEPORT, LONG ISLAND

This postcard reveals two aspects of Guy Lombardo during his tenure at Jones Beach: his restaurant (Guy Lombardo's East Point House) and his love of speedboating. From 1946 to 1949, Lombardo reigned as US champion, winning the Gold Cup and the Ford Memorial competition. He won the President's Cup and Silver Cup in 1952. A Freeport resident—a local street was named after him—Lombardo loved commuting to Jones Beach on his boat. On this postcard, however, it was added in.

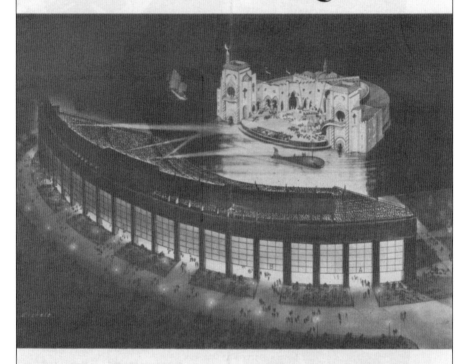

GUY LOMBARDO
presents
LAURITZ MELCHIOR
in
"Arabian Nights"

JONES BEACH MARINE THEATRE
Wantagh, New York

This early playbill is what patrons received at the Marine Theater during the run of *Arabian Nights*. It states that Lombardo's philosophy of giving the public what it wanted prompted him to produce it. Danish-born Lauritz Melchior was by this time an established Wagnerian tenor and a mainstay at the Metropolitan Opera Company from 1926 to 1950, during which he sang in 519 performances. He also performed in five Hollywood musicals for MGM and Paramount from 1944 to 1952.

JONES BEACH STATE PARK
PROGRAM 1957

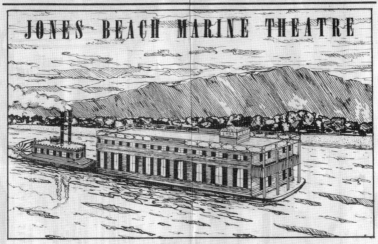

JONES BEACH MARINE THEATRE

GUY LOMBARDO presents

"SHOW BOAT"

Starring ANDY DEVINE as CAPTAIN ANDY

MUSIC by JEROME KERN
BOOK AND LYRICS by OSCAR HAMMERSTEIN 2nd
BASED ON THE NOVEL by EDNA FERBER
with GUY LOMBARDO & HIS ROYAL CANADIANS

NIGHTLY AT 8:30 Reserved Seats $1.10, 2.20, 3.30 & 4.40
RESERVATIONS AT MARINE THEATRE BOX OFFICE; ADMINISTRATION BUILDING ON THE
BOARDWALK; BROADWAY THEATRE — BROADWAY AT 53rd STREET — NEW YORK CITY
MEADOW BROOK NATIONAL BANK OFFICES AT WANTAGH, LYNBROOK,
WEST HEMPSTEAD, MANHASSET AND EAST MEADOW
SECURITY NATIONAL BANK OFFICES AT HUNTINGTON, PORT JEFFERSON AND BABYLON
LONG ISLAND RAILROAD TERMINALS AT PENN STATION, FLATBUSH AVE. & JAMAICA
Food Service at the Marine Theatre for Theatre Patrons

BOARDWALK RESTAURANT	**MARINE DINING ROOM**
At the Central Mall Noon to Midnight	At the West Bathhouse 5:30 P.M. to 9:00 P.M.
LUNCHEON — DINNERS — OPEN TERRACE	COMPLETE BUFFET SERVICE AT $2.75
SPECIAL SHOW BOAT DINNER	ALSO COCKTAILS
PARKING FOR PATRONS—ADJOINING RESTAURANT	PARKING FOR PATRONS—ADJOINING RESTAURANT

SOFTBALL (Co-Sponsored by Abraham & Straus) **NIGHTLY AT 8:30 P.M.**
ALSO LITTLE LEAGUE GAMES - SATURDAYS STARTING 11:00 A.M. & SUNDAY 1:00 P.M.
AT THE SOFTBALL STADIUM NEAR EAST BATHHOUSE — NO CHARGE

SPECIAL EVENT NO CHARGE TALENT CONTEST—RACES—PRIZES
CHILDREN'S DAY—For Boys and Girls Under 11 years—Wed., July 10—11:00 A.M.

OUTDOOR DANCING **9:00 P.M. to 11:30 P.M.**
NIGHTLY EXCEPT THURSDAYS — WALLY RHODES & ORCHESTRA
THURSDAY NIGHTS — SQUARE & FOLK DANCING
ED DURLACHER & "THE TOP HANDS" — AT THE MUSIC SHELL — NO CHARGE

POLO GAMES EVERY SUNDAY AT 3:30 P.M., BETHPAGE STATE PARK, FARMINGDALE

PLEASE HELP TO KEEP YOUR PARK CLEAN — DEPOSIT REFUSE IN BASKETS
DOGS NOT PERMITTED ON WALKS OR BEACH AT ANY TIME — PARK CLOSES AT 1 A.M.
7/2/57-100M

This 1957 flyer prominently names Andy Devine as Captain Andy in the production of *Show Boat*. Andrew Vabre "Andy" Devine appeared largely as a character actor in more than 400 films and was known for his distinctive wheezy voice. Ever versatile, he also performed extensively on radio and TV into the 1970s (he died in 1977). *Show Boat* at Jones Beach marked his stage debut.

It seems inevitable that the Jones Beach Theater would become a venue for performances far different from the genteel productions taking place during Robert Moses's tenure. Given his sense of propriety, he would have certainly frowned upon rock stars arriving at Jones Beach to perform. Yet this handbill printed in 1997 shows that they did. It turns out that, like everything else, Jones Beach was hardly immune to what the passage of time brings.

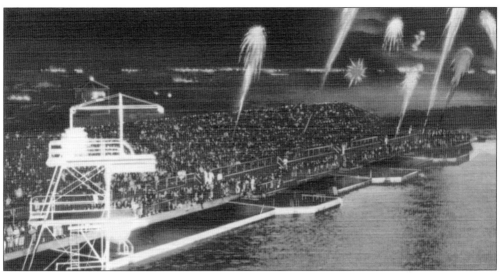

The Tomlin Art Company was responsible for this postcard. Local historian Julian Denton Smith recalled that "the fireworks on Zachs Bay . . . were monstrous things. . . . Rockets burst with three or four sprays from a single shot. . . . Sets showed the American flag . . . [and] enormous letters spelled out JONES BEACH. The shows . . . ended in [an] ensemble of rockets . . . and terminally a mighty blast from an earth-shaking aerial bomb. . . . [M]any an appreciative 'Oh' and 'Ah' sounded all around."

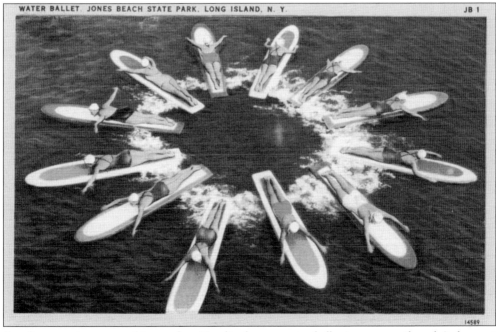

Another arresting postcard image from Tomlin shows a water ballet in progress, though it does not specify where. Here, it appears that the sum is greater than the parts, as the swimmers going in all different directions seems to present a flower in full bloom or a starburst.

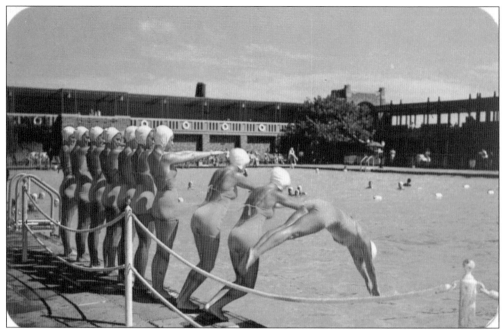

Unlike the prior postcard image, this Kodachrome shows the onset of a water ballet at the West Bathhouse. Notice their synchrony, the appearance of which blends an elevated performance with aquatics. Julian Denton Smith notes the performance's popularity: "The audience jammed the balcony around the pool, filled outside the fence and crowded into the standing room-only on the roof of the Marine Dining Hall." Nevertheless, Moses cancelled these performances to eliminate conflict with the water shows at the Marine Stadium.

This image of the boat basin at Zachs Bay is suggestive of the earlier scene of High Hill residents taking to their boats for a day of fishing (see page 23). The difference here, of course, is that more people can now have a chance of landing "the big one"—or to later, over a beer, tell the story of how it got away.

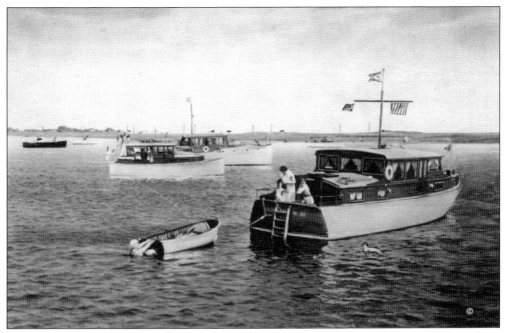

A most unusual scene was taken of the anchorage at the state boat channel. Why would someone be clinging on to the back of the dinghy? And who thought this was suitable for a postcard?

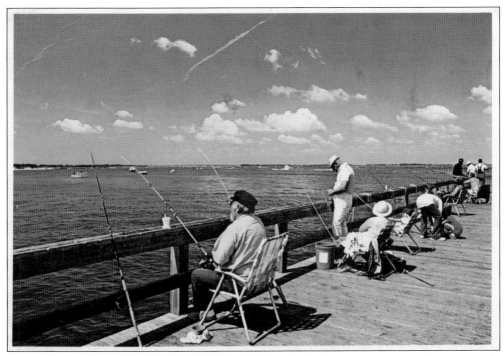

For those preferring to do their fishing while situated firmly on the ground, dock fishing at Zachs Bay makes for an ideal afternoon. Depending on the season, dock fishermen would usually fish for snapper or porgy, while (as noted earlier) blues and fluke required a boat trip into the deeper parts of the bay.

Here are two souls casting their reels in the ocean's active surf. While the fisherman above is forced to contend with constant breakers, his counterpart below seems to have a better time of it. The latter's silhouette makes for a more attractive postcard.

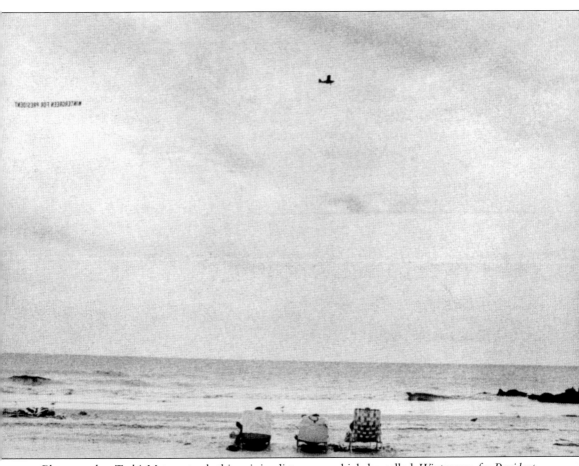

Photographer Toshi Matsuo took this minimalist scene, which he called *Wintergreen for President* (noting the banner to the left) in 1974. Again, there is no set way to enjoy the beach; here, three visitors unwind by the ocean as only they know how. The oceanfront is unusual in its calmness, which allows for the three friends to relax together.

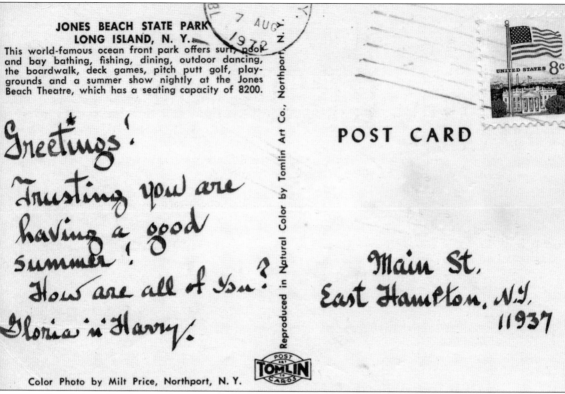

JONES BEACH STATE PARK
LONG ISLAND, N. Y.
This world-famous ocean front park offers surf, pool
and bay bathing, fishing, dining, outdoor dancing,
the boardwalk, deck games, pitch putt golf, play-
grounds and a summer show nightly at the Jones
Beach Theatre, which has a seating capacity of 8200.

Greetings!
Trusting you are
having a good
summer!
How are all of You?
Gloria 'n' Harry.

POST CARD

Main St.
East Hampton. N.Y.
11937

Reproduced in Natural Color by Tomlin Art Co., Northport,

UNITED STATES 8c

Color Photo by Milt Price, Northport, N. Y.

For all the telling images its postcards had over the years, a message from Jones Beach seems to be a fitting way to conclude this book. Though the message written on this postcard is brief, its flawless calligraphy would have no doubt added to the delight of its recipient. It only shows that, unlike text messages, a postcard in the thick of the day's mail never failed to offer a touch of humanity.

BIBLIOGRAPHY

Adams, Julian, ed. *Jones Beach State Park: Historic Structures & Cultural Landscape Report, 2013.* Albany: Division for Historic Preservation, New York State Office of Parks, Recreation & Historic Preservation, 2013. parks.ny.gov/inside-our-agency/documents/JonesBeachHistoricStructuresandCulturalLandscapeReport.pdf.

Caro, Robert A. *The Power Broker: Robert Moses and the Fall of New York.* New York: Alfred A. Knopf, 1974.

Hanc, John. *Jones Beach: An Illustrated History.* Guilford, CT: Globe Pequot Press, 2010.

Krieg, Joann P., ed. *Robert Moses: Single-Minded Genius.* 2nd ed. Interlaken, NY: Hearts of the Lakes Publishing, 2000.

Kroessler, Jeffrey. "Long Island State Parks Commission and Jones Beach." *Robert Moses and the Modern City: The Transformation of New York.* Ballon, Hilary and Kenneth T. Jackson, eds. pp. 158–160. New York: W.W. Norton, 2007.

Pozderec, George P. *Jones Beach: An American Riviera.* POZ Productions, Inc., VHS 1998, DVD 2006.

Smith, Julian Denton. "High Hill Beach." *Nassau County Historical Journal* 32, no. 2 (1972): 1–14.

———. "Jones Beach: Before the Throngs." *Nassau County Historical Journal* 31 (1971): 21–29.

DISCOVER THOUSANDS OF LOCAL HISTORY BOOKS
FEATURING MILLIONS OF VINTAGE IMAGES

Arcadia Publishing, the leading local history publisher in the United States, is committed to making history accessible and meaningful through publishing books that celebrate and preserve the heritage of America's people and places.

Find more books like this at
www.arcadiapublishing.com

Search for your hometown history, your old stomping grounds, and even your favorite sports team.

Consistent with our mission to preserve history on a local level, this book was printed in South Carolina on American-made paper and manufactured entirely in the United States. Products carrying the accredited Forest Stewardship Council (FSC) label are printed on 100 percent FSC-certified paper.

MADE IN THE USA